FLOWER POUNDING

QUILT PROJECTS FOR ALL AGES

Ann Frischkorn and Amy Sandrin

C&T PUBLISHING

Editor: Beate Nellemann
Technical Editor: Lynn Koolish
Cover Designer: Aliza Kahn
Book Designer/Design Director: Aliza Kahn
Production Coordinator: Diane Pedersen
Production Assistant: Kirstie L. McCormick
Illustrator: Richard Sheppard © C&T Publishing, Inc.
Watercolors: Diane Pedersen © C&T Publishing, Inc.
Flower Photos on pages 48, 52, 55, 59, 61: Stacy Chamness and Diane Pedersen
Front Cover: *Paint Me A Garden* by Amy Sandrin
Back Cover: *Catching Air* by Anthony Sandrin

Attention Teachers: C&T Publishing, Inc. encourages you to use
this book as a text for teaching. Contact us at 800-284-1114 or
www.ctpub.com for more information about the C&T Teachers Program.

Library of Congress Cataloging-in-Publication Data

Frischkorn, Ann,
Flower pounding : quilt projects for all ages / Ann Frischkorn and Amy Sandrin.
 p. cm.
Includes bibliographical references and index.
 ISBN 1-57120-116-5 (paper trade)
 1. Quilting. 2. Textile crafts. 3. Flowers in art. I. Sandrin, Amy,
1961- II. Title.
 TT835 .F755 2000
 746.46--dc21

 00-009222

Published by C&T Publishing, Inc.
P.O. Box 1456
Lafayette, California 94549

Printed in Hong Kong
9 8 7 6 5 4 3 2 1

CONTENTS

Dedication

This book is dedicated to our husbands, Dave and Don, and our children, Anthony, Eric, Kate, and Kyle, who enthusiastically supported us through this entire journey. We love you all!

Acknowledgments

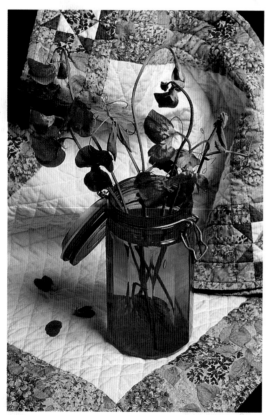

They say a picture is worth a thousand words. Don, yours are worth a million. You outdid yourself. Mere thanks are not enough.

Very special thanks to our Mom, Helen Dworzynski, who always encouraged our creative endeavors.

Thanks to Beate Nellemann, editor extraordinaire at C&T Publishing, for coming up with brilliant ideas that helped to make this book better than we ever imagined. Last but not least, thanks to the rest of the C&T team: Lynn Koolish, Aliza Kahn, Diane Pedersen, and Kirstie McCormick for making our dream a reality.

INTRODUCTION

There is nothing more sentimental and timeless than a flower pressed between the pages of a book. But how often does one actually seek out these sentimental riches and reminisce? Can you imagine proudly displaying a rose from your wedding bouquet, your daughter's prom corsage, or a flower from the first garden you ever planted in your home? Wouldn't it be wonderful to gaze upon these mementos every day instead of only when you happen to flip between the pages of your dusty dictionary searching for how to spell the word florilegium?

In this book, you will discover exactly how to take your precious floral treasures and turn them into a keepsake quilt that will outlast your memories.

We first discovered flower pounding when Ann read an article in a children's magazine about pounding leaves. Leaf hammering is an ancient method of transferring the delicate patterns of leaves to cloth. It is said to have been used by Cherokee women, who used wood ash as the fixer. Ann wondered if the same method would work with flower petals. It works beautifully.

TOOLS AND SUPPLIES

EVERYTHING YOU NEED TO PUT THE METAL TO THE PETAL

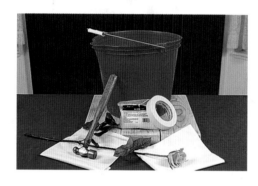

- Alum
- Washing soda
- Muslin
- Bucket
- Hammer
- Masking tape
- Pounding board
- Scissors
- Flowers
- Towel

Alum

Alum is a white powder that helps the muslin absorb and hold fast the flower or plant pigment. It can be purchased at any art supply store. In a pinch, you can buy smaller amounts from a pharmacy or in the spice aisle of your grocery store.

Washing soda

Along with the alum, washing soda is used to treat the fabric. This chemical substance eliminates the sizing and finishing additives that might impede the flower-dyeing procedure. You can purchase washing soda at a grocery store or an art supply store.

Muslin

Muslin is to flower pounding as canvas is to paint. There are many different shades and types of muslin to choose from. Each will produce different color effects. Try a wide variety until you find the muslin that provides the best color result for you, but be sure it is 100% cotton.

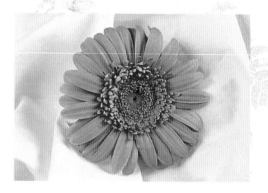

We recommend treating as much of the muslin as you can at one time. There is nothing worse than being in the middle of a flower pounding session only to discover you are out of treated muslin.

(Maybe we can think of one thing worse. Have you ever reached into a bag of M&M's only to discover you have already eaten the last one?)

Use a lightweight hammer to prevent your arm from getting tired.

Bucket

You will need a good sturdy bucket to soak the muslin in overnight (or at least a minimum of eight hours). If you don't have a bucket, find a container large enough to treat the amount of fabric you have selected. For example, a sink or laundry tub will work just as well.

Hammer

A hammer is used to pound the pigment from the flower petals, transferring it to the fibers of the material. Select one with smooth edges on the head, as rough or sharp edges can tear a hole in your fabric.

After experimenting, we eventually arrived at a preferred type of hammer: a medium-sized metal machinist hammer. It didn't matter if the hammer was metal, rubber or hard plastic; they all produced the same results. It really comes down to a personal choice.

Masking tape

Masking tape is used to stabilize the flower petals on the muslin and to keep them from moving while you hammer. We found that the one-and two-inch width masking tapes are good sizes to have on hand and are easy to work with.

Pounding board

A thick cutting board or a piece of scrap lumber will work as a pounding board. Place the muslin on the board instead of directly on a table or counter when you are hammering. This will prevent damage to your work surface. The harder the wood the better—oak is an excellent choice. Softwoods, such as redwood or pine, will develop divots from repeated hammering. These divots ruin the flat, smooth surface and prevent you from getting a good clean imprint of pigment. In order to extract the maximum amount of pigment from the flower petals, you must pound on a hard, flat, and smooth surface.

Scissors

Take scissors along on your flower hunting excursions. They are invaluable for snipping thick stems. You will also use them during the pounding process for cutting pieces of masking tape and for cutting flower petals and leaves into the desired shapes.

Flowers

You should think of the flowers as paint, so select a wide variety for your palette.

Place a small towel under your pounding board to further protect your work surface and muffle the sound.

FABRIC SELECTION AND PREPARATION

Selecting fabrics play an important role in flower pounding. Natural fabrics, such as plain 100% cotton muslin, work best. The organic fibers in the muslin pick up the pigment of the flowers and plants better than blended cloth, such as a poly/cotton blend. The muslin is also strong enough to withstand repeated hammering. When you begin your own flower pounding, you will understand this, loud and clear.

There will be times when a project calls for fabric other than plain muslin, such as *Climbing the Walls* on page 29 and *Room with a View* on page 31. As long as the fabric is 100% cotton and light enough in color that the pigments of the flowers show up, it should work.

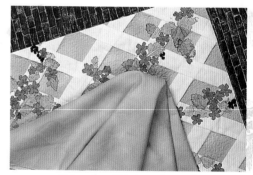

Light-colored fabric can be used instead of plain muslin.

THE STEPS

After the muslin is selected, wash it in hot water using regular laundry detergent and two tablespoons of washing soda. This step removes sizing and finishing additives, which might hinder the transfer of rich color from the petals or leaves. Make sure to run the muslin through the rinse cycle two or three times to ensure that all traces of the washing soda are thoroughly removed.

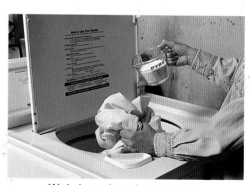

Wash the muslin with washing soda.

> If you iron the muslin right before it is completely dry, the wrinkles will come out more easily.

The next step is to treat the muslin with alum. Alum is not harmful to the skin, but if you have sensitive hands consider wearing rubber gloves. Take the muslin from the washing machine and place it into a bucket, very large bowl, or laundry sink—whichever will accommodate all the muslin you wish to treat. Add two cups hot water and ¼ cup alum for each yard of muslin. If needed, add more water to immerse the muslin.

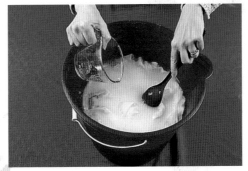
Adding alum to the bucket with fabric.

Don't worry if some of the muslin floats above the water surface. Simply stir the muslin around a few times during the treatment and it will be fine. If you decide to add more water, don't add more alum. Stir until all the alum is dissolved, and then allow the liquid to cool. This could take several hours.

In a separate cup or bowl, dissolve washing soda (one teaspoon for each yard of muslin) in a small amount of hot water (approximately ¼ to ½ cup). Add this mixture to the container holding the muslin. Be careful, because it might fizz like a witch's cauldron. Don't worry—this is normal and, we think, kind of fun.

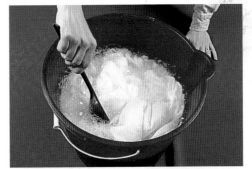
Add washing soda and watch it fizz.

Let this concoction soak overnight. In the morning (or after at least eight hours time) wring out the treated muslin—do not rinse—and hang it up to dry naturally. When it is almost dry, press out any creases and cut into the desired sizes for your projects.

Now you are ready for the really fun part—selecting, picking, and pounding your flowers.

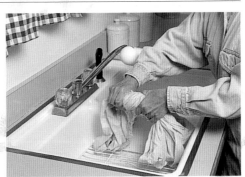
Wring excess water out of muslin.

If treating three or more yards of muslin at one time, it is easier to handle if the fabric is cut into one yard pieces.

SELECTING AND POUNDING FLOWERS

THE METHOD BEHIND THE FLOWER POUNDING MADNESS

At this point, your muslin is treated, dried, and pressed, and it is now time to go on a flower hunt. This may be as simple as walking out the door to your own garden or as involved as a flower excursion around the neighborhood, town, or even out into the country. Flower pounding isn't reserved for summers only. In the dead of winter, visit the florist or the floral section of the grocery store. If you've got a green thumb, try growing your own indoor flowering plants during the cold months.

Before leaving home, you should make some simple preparations for when you return with your collected flowers. Once picked, some flowers tend to wilt quickly if not placed in water. We like to have a vase with water ready and waiting. Also, prepare your work area so that you are ready to pound as soon as you return. All flowers should be handled with care. However, we have found that some, such as the morning glory, are especially fragile and rip easily. We like to bring a separate box in which we place fragile flowers.

If you happen to spy a flower in a neighbor's yard that you just can't live without, make sure you ask permission to pick it first. When friends find out what you are using the flowers for, they are usually more than happy to part with some. Be prepared to pay the price, though. They may ask you to settle the deal with a quilted wall hanging in exchange for some of the bounty from their garden. Another alternative is a midnight flower-borrowing reconnaissance mission, with flashlight in hand!

Warning: Flower hunting is almost as addictive as flower pounding. From the first project you will be hooked. It will be impossible to go anywhere without scanning your surroundings for unusual colors, varieties, and shapes. When we first discovered this art form, every time we hit the brakes on the van, our kids would roll their eyes and groan, "Not again!" We quickly learned that getting them involved ended all their complaints in a heartbeat. See page 17 on including children in your fun, and the wonderful creations they can make. Spouses can also be involved in this sidetracking maneuver.

On longer road trips take your hammer, scissors, tape, muslin, and board with you in the car so you can pound on-site.

The Steps

The first step is to decide where to place the flower on your muslin. Try starting in the center and working out toward the edges. Leave plenty of room around the edges to allow for seam allowances.

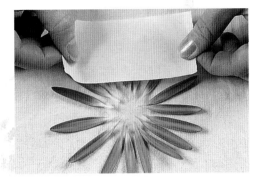

Flower petals are taped in place.

Tack a few petals at a time. Work around the flower until they are all secure.

When working with tiny petals, sometimes it is easier to place them directly on the masking tape first, and then apply the tape to the muslin.

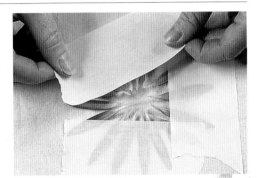

Taping petals

After the petals are tacked down, cut off any remaining stems to prevent green pigment from mixing with the petal color.

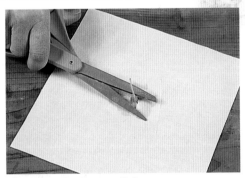

Cutting off the stem

Make sure the entire flower is covered with tape.

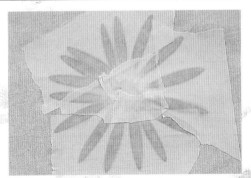

Covering the petals

Cut a number of pieces of masking tape in advance and line them on the edge of the counter/table for quick and easy access.

Flip the cloth over to the reverse side, lay it on your pounding board and start pounding.

One gentle warning: Flower pounding can run on the loud side.

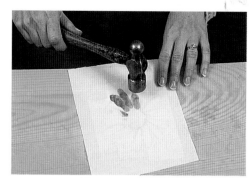

Hammering the petals

When you are finished hammering you shouldn't be able to see any "muslin white" where the petal is.

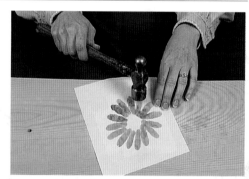

Finish hammering

When you feel you have transferred all the pigment, turn the muslin over and carefully pull off the tape.

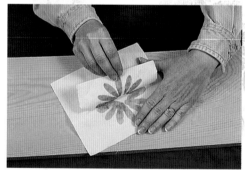

Pulling off the tape

You may need to scrape off remnants of the petal using a dull butter knife or you can use your fingernail.

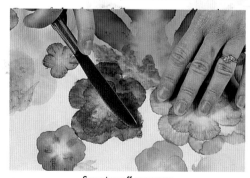

Scraping off remnants

You'll quickly discover how much force you need to use with your hammer. The power you need to apply also varies from flower to flower. Pound until the pigment in the petal bleeds through solidly to the material.

Part of the fun of flower pounding is watching your creations "bloom" and come to life. The color of the petal doesn't always reflect the color that will end up on the fabric. We have also seen the flowers from the same plant, picked on different days, yield a variety of shades.

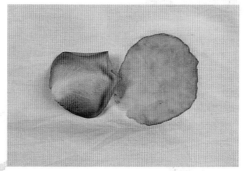

The color you end up with is rarely the same color as the actual flower.

Most flowers produce a nice petal shape when pounded.

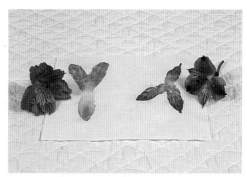

Two fresh and two pounded petals.

Begonias, tulips, and some, but not all, lilies are so juicy they result in nothing more than a colorful blob, which adds wonderful variety and color to the quilted piece. The waxy substance in a begonia also causes some interesting color variations.

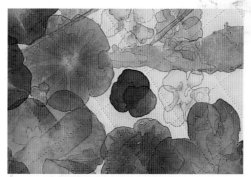

Red begonia adds interest to flower pounding.

Test a petal on a piece of scrap muslin first to determine the color it will produce.

For bulky flowers, such as marigolds, roses, and carnations, it works best to remove some petals and the stamen from the stem, and then arrange them on the muslin.

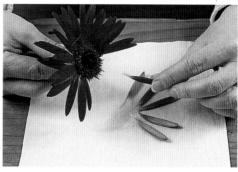

Instead of pounding the entire flower, pluck just a few petals.

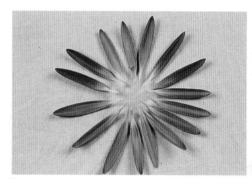

Arrange the petals as desired.

We have found that using an entire flower at one time does not give a clear imprint of the petals. If you decide to pound one petal at a time, pound it, let it dry, then slightly overlap the next petal; you will end up with a sharp distinction between the petal imprints. The result will look more like the flower with which you started.

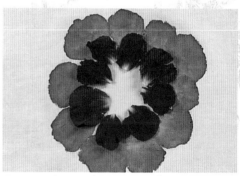

Arrange the inner row of petals touching the outer row.

Impatient for the pigment from the petal to dry? You can use a hair dryer, set on low, to speed up the process.

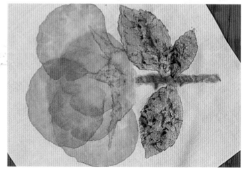

Overlapping petals add dimension.

Don't forget to add some leaves along with your petals. When pounding leaves, tape them vein-side down. This will produce a much better imprint of the leaf.

After some practice, you will find it is no problem to tape more than one flower at a time before you turn the muslin over and begin pounding.

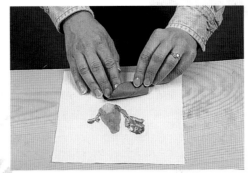

Pound leaves vein-side down.

Step back from your project often. Distance gives a different perspective where you can discover holes that need to be filled in or a spot that is calling for a bright splash of color. Some good fillers to work with are florets, such as verbena, kalanchoe, and alyssum. Greenery that works well includes evergreen branches, asparagus fern, dill, baby's breath, and, on occasion, the ever-persistent weed. Hey, they have to be good for something!

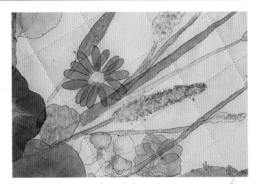

Pounded weed

If you don't have a design wall, put your project on the refrigerator with magnets.

Weeds also make great fillers.

When you are happy with your arrangement and feel it is complete, run a dry iron on a medium setting over it. Don't use steam—it will ruin the color of the transferred pigment. Too hot of a temperature will scorch the pounded flowers, so be careful. The proper amount of heat will set the color in the muslin. Though the iron heat helps set the color, the finished project should never be immersed in water or dry cleaned, because the richness of the colors will fade or bleed. We have noticed that the brighter the room, the more the colors fade. Therefore, avoid hanging your quilt where it might be exposed to direct sunlight.

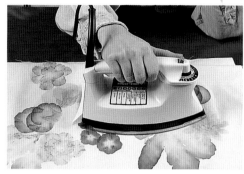

Iron on a medium setting.

The last step, which brings added definition to the arrangement, is to further define the edges and lines with a permanent, fine-line fabric marker. These can be purchased at any fabric, craft, or art supply store.

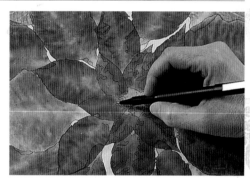

Black or brown markers add a nice finishing touch.

For the outlining step, we always use black, but experimenting with different colors may provide unexpected and wonderful results. Lightly trace the shadows and changing color patterns. Trace as much or as little as you like. This is a personal preference.

Start with the finest point marker first. You can always add extra if your lines are too light, but you can't take away if they are too dark.

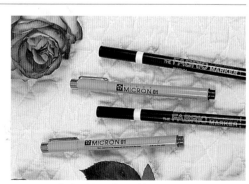

Several brands we like to use are Micron Pigma™ and Marvy™.

Check the picture gallery in this book to spark your own creative imagination. The possibilities are endless. Don't be discouraged if your first attempts are less than satisfactory. Practice makes perfect.

GETTING KIDS INVOLVED

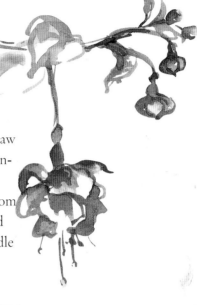

MOM, CAN I BORROW YOUR HAMMER?

Flower pounding is not just for adults. When our children saw how much fun we were having with flower pounding, they insisted on joining us. At one point, with over six people hammering at the same time, we competed with the construction site across the street. A curious neighbor walked over to see what we were "building." When she saw the kid's beautiful creations, she volunteered to part with flowers from her own garden. Our kids range in age from five to twelve. We do not recommend letting a child who cannot safely handle a hammer do any flower pounding.

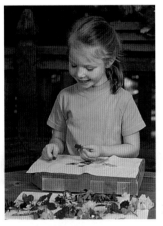

Kate decides where to place her flowers.

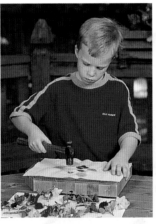

Eric puts the metal to the petal.

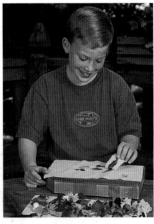

Kyle checks his results.

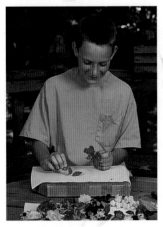

Anthony chooses his favorite color.

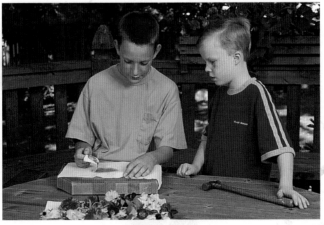

"Hey, Anthony, I'll trade you a begonia for a petunia."

Flower Pounding would be a fun project for Scouting troops.

Children are very creative. Without the limitations normally reserved for adults, they arrange their floral designs in wonderful and exciting patterns. Though they usually know where they want to place flowers, smaller children might need help taping the petals to the muslin.

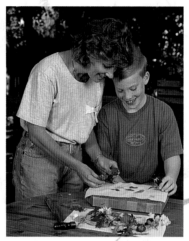
Teamwork at its best

Projects created by children make wonderful gifts for teachers, music instructors, and grand-parents—just to mention a few.

JACK

Marigolds were pounded through a hand-made pumpkin-shaped stencil. The stem was pounded using a leaf. The eyes, nose and mouth were embroidered by hand, using three-ply floss thread. The black pumpkin and green stem outlines were satin stitched on the machine.

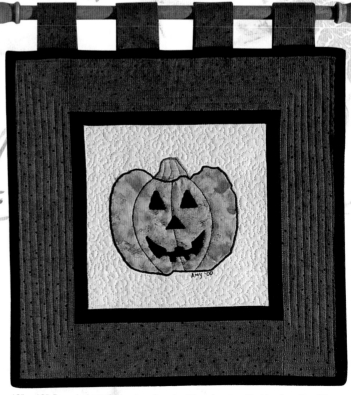
12" x 12". Pounded, machine pieced, embroidered, and quilted by Amy Sandrin.

SCIENCE PROJECT

Eric was proud that he pounded this entire quilt by himself without any adult interference. The border fabric he selected looks like something you would see under a microscope.

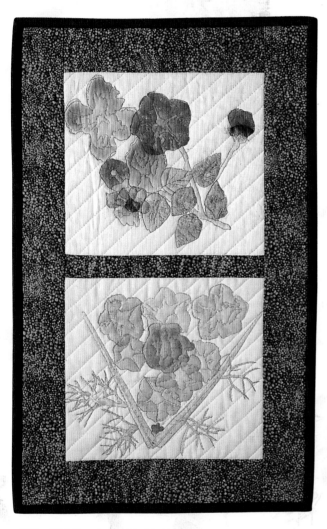

13½" x 21¼". Pounded by Eric Frischkorn.
Quilted by Ann Frischkorn.

FLORAL BALLET

This quilt was created in a marathon quilt pounding session around Grandma's kitchen table. Eight people wielding hammers is a sound we will never forget. Kate had fun spending time with her cousins and making a quilt for her bedroom.

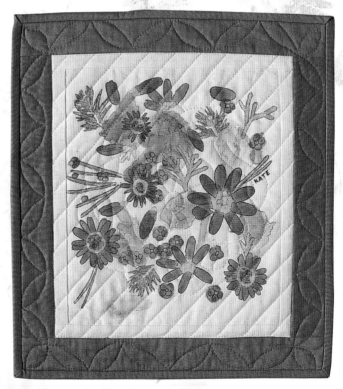

12" x 13". Pounded by Kate Frischkorn.
Quilted by Ann Frischkorn.

CATCHING AIR

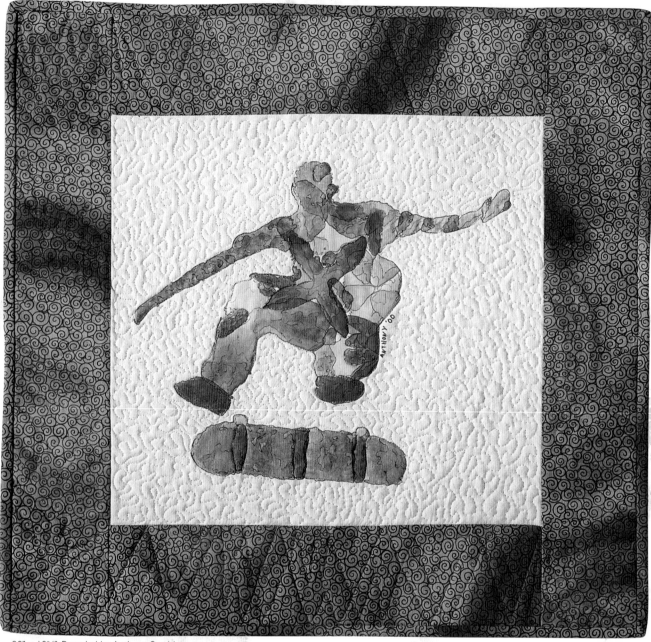

20" x 18¾". Pounded by Anthony Sandrin.
Quilted by Amy Sandrin.

Being a typical boy, Anthony wanted to combine his love of skateboarding with his quilt. He cut the shape of a skateboarder out of template plastic and pounded a variety of flowers through it. For the border, he selected a wild fabric that matched the color of his bedroom.

Directions for Catching Air

Copy and enlarge the pattern 200% then trace onto a sheet of template plastic. Anthony's skater is approximately 12" x 10". Cut out the stencil. Center the stencil on a piece of muslin, allowing ample room for seam allowances, and tape into place. Cover the stencil with flower petals, tape down, and pound. Using a permanent, fine-line fabric marker, outline all the flowers. Attach borders, layer, and quilt as desired.

Enlarge 200%

UNDERSEA ADVENTURE

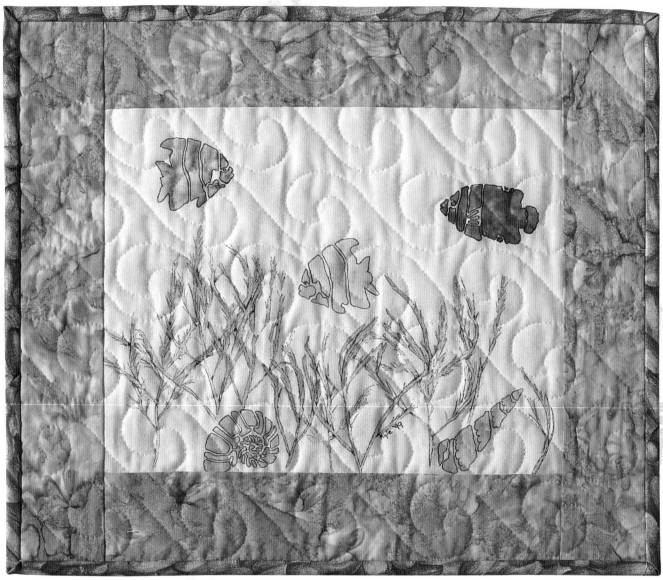

16¾" x 14". Pounded by Kyle Frischkorn.
Quilted by Ann Frischkorn.

The fish and shells were pounded through a stencil. To give an ocean effect, "waves" were quilted across the entire top of this quilt.

Directions for Undersea Adventure

Copy and enlarge as desired the patterns on this page, and trace onto a sheet of template plastic. Cut out the stencil. Place the stencil in the desired spot on your muslin, allowing ample room for seam allowances, and tape it into place. Cover the stencil with flower petals, tape down, and pound.

Repeat with additional fish and shells. Use dillweed to create the seaweed. You can flip the template over to add fish swimming in the opposite direction.

Using a permanent, fine-line fabric marker, outline the fish, shells, and seaweed.

Attach borders, layer, and add quilting to give an ocean wave effect.

My Notes:

GALLERY

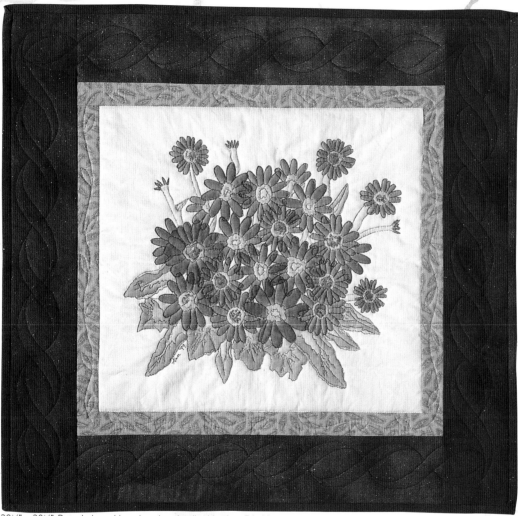

20½" × 20¼". Pounded, machine pieced, and quilted by Ann Frischkorn.

Midnight Oasis

These flowers were purple cineraria. I took each petal off the stem one at a time and arranged them in the flower's pattern to get more definition. After these were pounded, I pinched out the centers, sprinkled them in the middle of each pounded flower, then taped and pounded them.

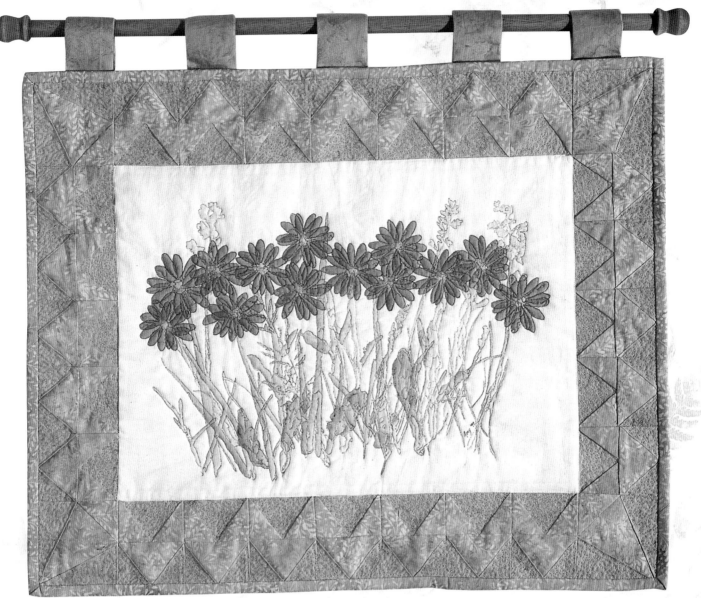

19" x 15". Pounded, machine pieced, and quilted by Amy Sandrin.
From the collection of Phyllis Williams.

Lucky Charm

My friend, Phyllis, is always sending me e-mails
telling me when good luck is headed my way.
When these daisies were the only flowers to
survive not one, but two hail storms, I knew
I had to incorporate them into a quilt for her.
I used grass as "filler." After pounding it, I realized
I had used 13 daisies in the quilt. I thought it
was a great oxymoron, considering the title and
the number of flowers used. Phyllis agreed. It
turned out that 13 was her special sorority
number when she was in college. In her eyes,
this made the quilt a real "lucky charm."

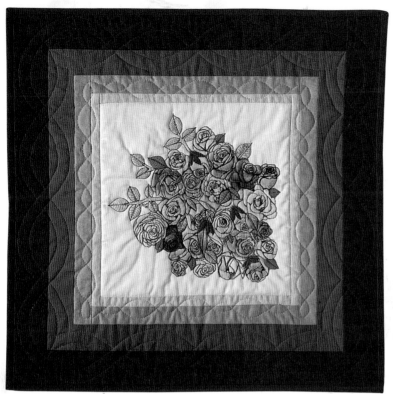

21" x 21". Pounded, machine pieced, and quilted by Ann Frischkorn.

To Have and to Hold

One way to preserve wedding memories forever is to pound the bridal bouquet. I really wanted to show a lot of detail in the roses, so I inked these heavier than I normally do.

How Does Your Garden Grow?

When I pounded the bright red gerbera daisies on this quilt, much to my surprise they turned out brown. I loved how they looked, but this is a perfect example of why testing on a scrap piece of muslin is a good idea. To pick up the brown theme, I incorporated brown into the binding. Other flowers I used in this quilt include kalanchoe, roses, carnations, and alstroemeria.

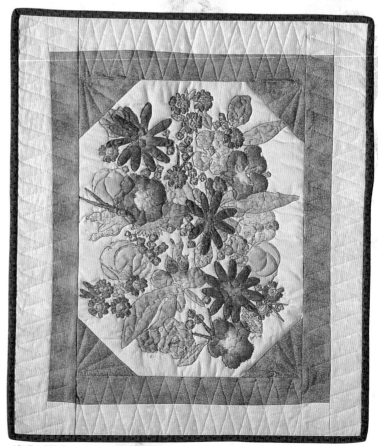

19½" x 23". Pounded, machine pieced, and quilted by Amy Sandrin. From the collection of Dan Dworzynski.

Garden Party

I used a store-bought stencil to pound the flowers and the butterfly on this quilt. I taped the stencil to the muslin, then taped the flower petals over the stencil and pounded. I used dillweed for the grass, tea roses in various colors, and snapdragons to pound through the stencils.

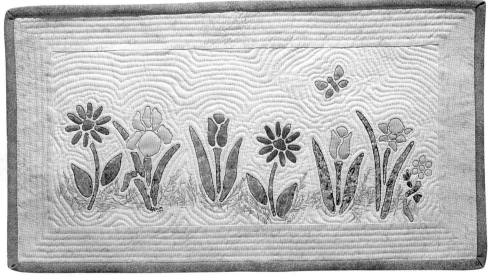

19¼" × 10¾". Pounded, machine pieced, and quilted by Ann Frischkorn.

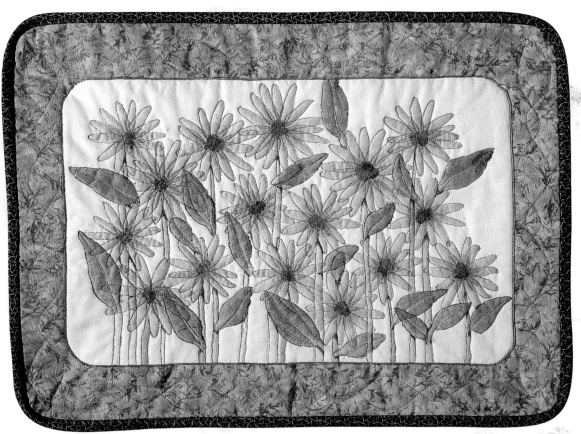

18¼" × 13¼". Pounded, machine pieced, and quilted by Ann Frischkorn.
From the collection of Dan Dworzynski.

Black-Eyed Susans

These black-eyed Susans make an appearance in my backyard at mid-summer every year. This quilt would brighten up any breakfast nook.

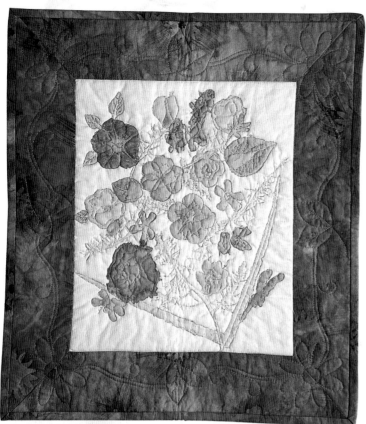

16" x 18". Pounded, machine pieced, and quilted by Ann Frischkorn.

Once Upon a Summertime

This is one of the first quilts I ever pounded. These flowers were picked from my own backyard and during walks about town. I love the "airy" feel to the bouquet. Batik fabrics lend themselves well to these projects. The flowers I used in this quilt include begonias, petunias, snapdragons, geraniums, roses, and marigolds.

Shadows in Bloom

I started this quilt with a shadow box in mind. I pounded nine separate blocks of five-inch squares. I used moss rose, carnations, Johnny-jump-ups, roses, and dianthus. This quilt is a good one to tackle if you need practice with mitered corners. Including the border, there are thirteen miters.

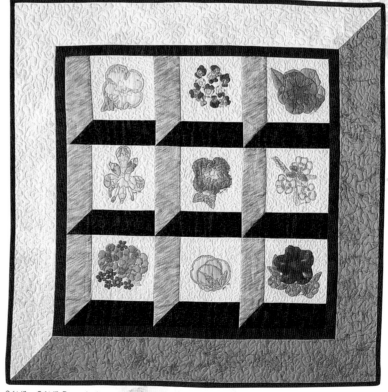

26½" x 26½". Pounded, machine pieced, and quilted by Amy Sandrin.

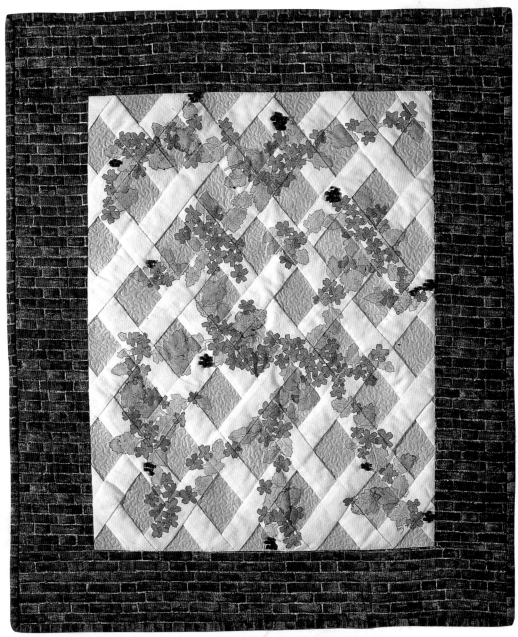

20" x 24". Pounded, machine pieced, silk ribbon embroidered, and quilted by Amy Sandrin. From the collection of Helen Dworzynski.

Climbing the Walls

I envisioned this quilt in my mind for months before I started it. I wanted it to look like the clematis trellis outside my front door. I knew I couldn't use the actual clematis for several reasons. I knew from experience they turned a brownish-black when pounded, and they were also too large. Instead, I used verbena and achieved exactly the look I wanted. To add a splash of color, I made clusters of tiny flowers with maroon silk-ribbon embroidery.

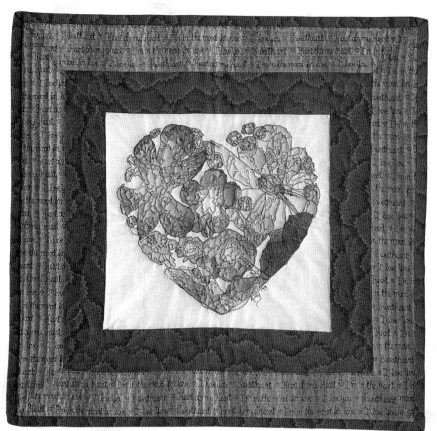

14" × 13½". Pounded, machine pieced, and quilted by Amy Sandrin. From the collection of Terri Clark.

Passionate for Purple

As a romance writer, I knew I had to use this fabric in a quilt because of the words "Heart of my heart" printed on it. Placing a heart in the center was the ideal choice. I made a stencil out of template plastic and used a variety of flowers that I had previously discovered would pound purple. The flowers I used in this quilt include alstroemeria, roses, carnations, and kalanchoe. This has quickly become a favorite amongst my romance writer friends. Many have their names on a list for one of their own.

Christmas Wreath

This quilt was pounded using arborvitae, a type of evergreen tree. The colored beads were sewn on as ornaments, and a red bow accented the lower left corner. Christmas fabric was selected to coordinate with the ornaments and bow.

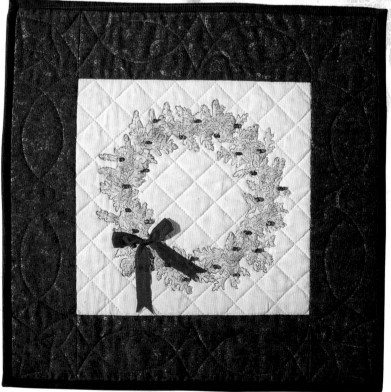

13½" by 13½". Pounded, machine pieced, and quilted by Ann Frischkorn.

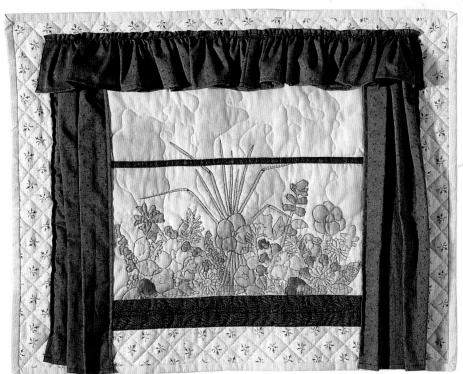

23¼" x 18½". Pounded, machine pieced, and quilted by Ann Frischkorn.

Room with a View

Above my kitchen sink is a window that gives me a view of the flower boxes on our deck. Doing the dishes is never a chore when I can gaze upon my favorite flowers. This quilt preserves the memory of that view year-round. The flowers I used in this quilt include salvia, verbena, impatiens, snapdragons, and marigolds.

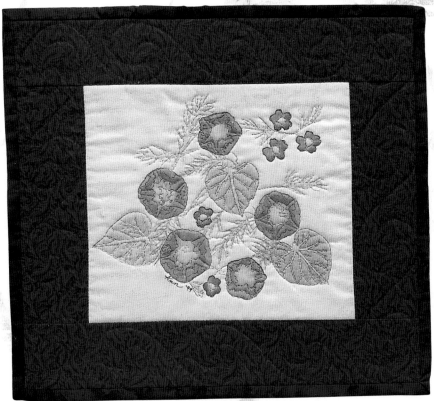

Top o' the Morning

I found these baby morning glories on a telephone pole. The petals were so fragile and ripped so easily that I knew they wouldn't survive the ride home. I pounded them on-site in the car. To fill in the spaces I used purple verbena and dillweed.

13½" x 12¼". Pounded, machine pieced, and quilted by Ann Frischkorn. From the collection of Eileen Lofgren.

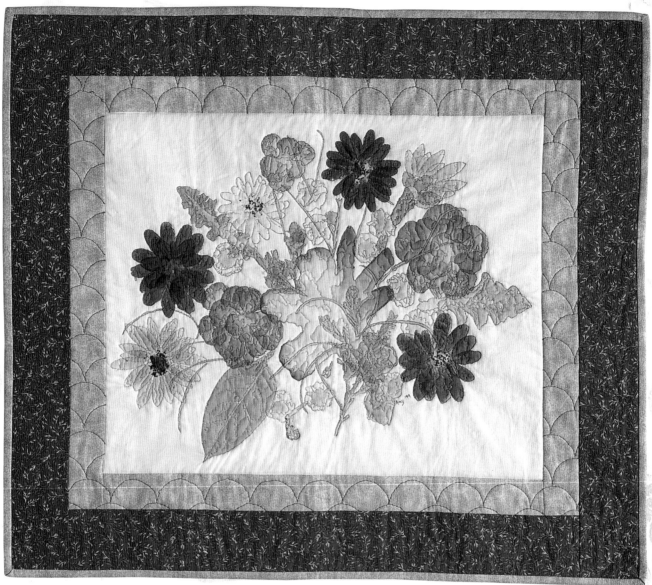

27" x 23". Pounded, machine pieced, and quilted by Amy Sandrin.

Snippets of Blue

My writing critique group gave this bouquet of flowers to me when I sold a historical romance for audio. I started with the iris in the center and was thrilled to find that the purple flower pounded blue. I also used red carnations and yellow sunflowers. I quilted the border using the clamshell pattern.

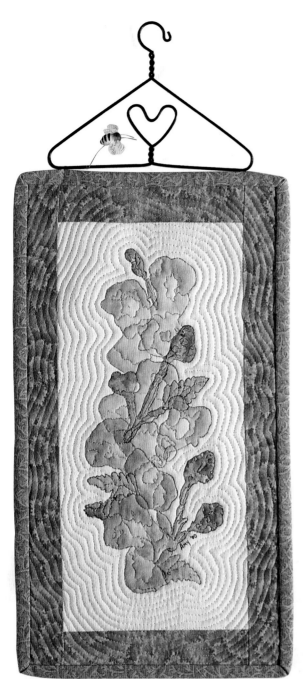

The Dragon's Lair

I pounded this quilt using snap-dragons. Bees are always buzzing around the snapdragons in my yard, so I thought I would add them to the quilt.

8" × 14¼". Pounded, machine pieced, and quilted by Amy Sandrin. From the collection of Anita Desiree Moore.

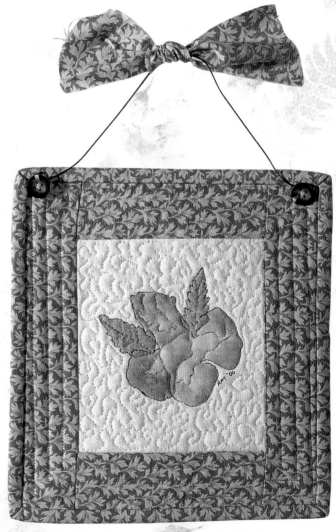

Aloha

This tiny quilt features a snapdragon. The border fabric reminded me of a Hawaiian shirt. I made a bow out of the same fabric and tied it to the wire to give it a softer look.

8½" × 9". Pounded, machine pieced, and quilted by Amy Sandrin.

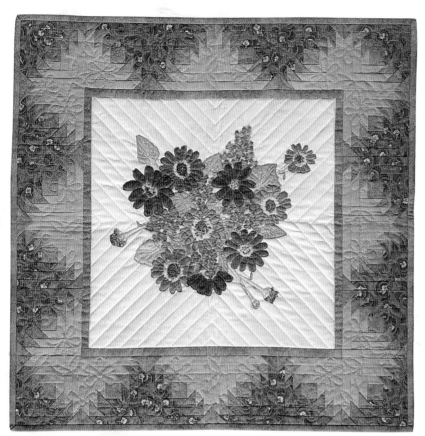

Twist of Fate

I found the cineraria used in this quilt while grocery shopping. I hadn't planned on pounding, but the flowers were so beautiful I couldn't pass up the opportunity. Thank goodness I always have plenty of prepared muslin on hand for such emergencies! The original flower was a bright magenta color. I was very happy that they pounded out reddish/pink. Up until this point, we hadn't found anything that would produce this particular color. I wanted to make a pieced border for this project and loved the South-Western look that the Log Cabin/Flying Geese block provided. The quilting pattern around the flowers seems to emphasize the Log Cabin pattern.

24" x 24". Pounded, machine pieced, and quilted by Ann Frischkorn. From the collection of Kate Frischkorn.

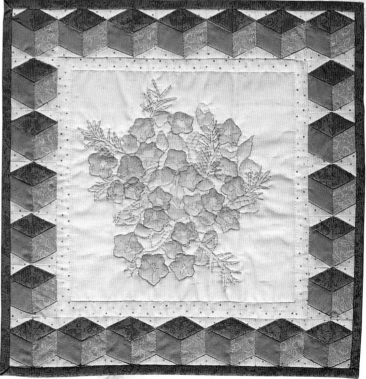

Snips and Snails

What better way to preserve the memory of a baby's birth than by pounding one of the arrangements you received in the hospital. I pounded this quilt using campanula, and yellow snapdragons. I couldn't think of a more appropriate border than tumbling blocks.

14" x 14". Pounded, machine pieced, and quilted by Ann Frischkorn.

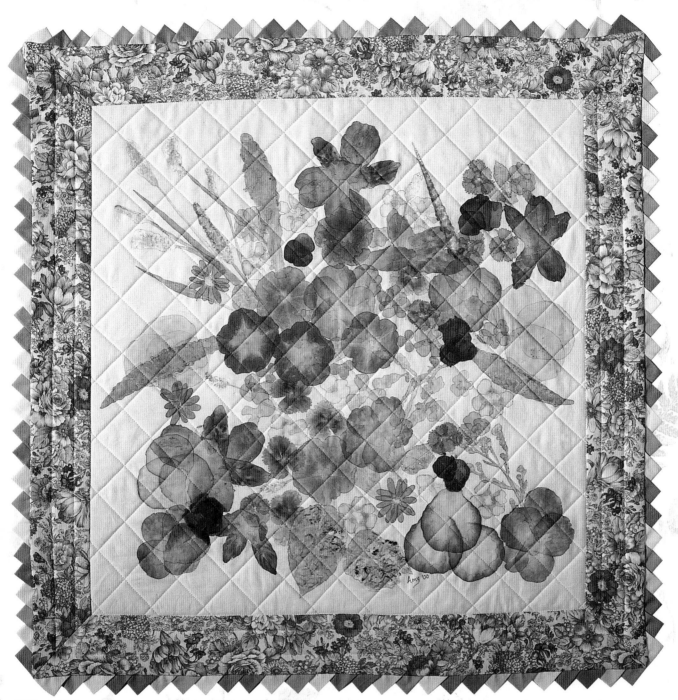

25½" × 25½". Pounded, machine pieced, and quilted by Amy Sandrin.

Home on the Prairie

I used a large assortment of flowers in this quilt, including moss rose, dianthus, begonias, petunias, and even some weeds. The entire top was grid quilted. The prairie points lend a different feel to the quilt.

Antique Rose

I surprised my friend, Deone, with this
rose-pounded quilt for her birthday.
I used a block called Bricks in the border,
and I grid quilted around the rose.

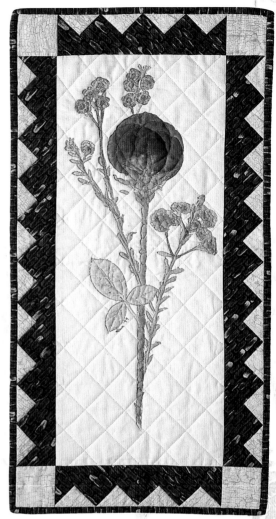

12½" x 24". Pounded, machine pieced, and quilted by
Ann Frischkorn. From the collection of Deone Matichak.

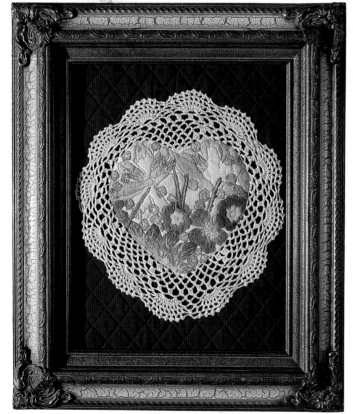

11" x 14". Pounded, and quilted by Amy Sandrin. From
the collection of Pegi Dworzynski.

Peg o'My Heart

My sister Pegi wanted a quilt for her purple bath-
room. I pounded these assorted flowers through
a heart-shaped stencil, then sewed it on top of a
doily, and centered everything onto a grid-quilted
deep purple background. I wanted to try some-
thing different for this quilt, so I framed this piece
instead of binding it. The flowers I used include
primrose, alstroemeria, kalanchoe, and carnations.

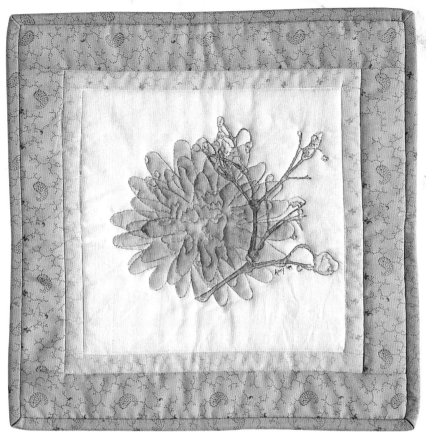

Pink Champagne on Ice

I pounded this quilt using a pink gerbera daisy and baby's breath. I choose a different border color than that of *Wild Thing* (shown below). Using different fabric can totally change the look and feel of a quilt. While this piece is soft and romantic, *Wild Thing* is, well, wilder.

11" x 11". Pounded, machine pieced, and quilted by Amy Sandrin.

Wild Thing

Just as in the quilt above, I pounded this one using a gerbera daisy — an orange one instead of pink. For an accent, I used a sprig of baby's breath.

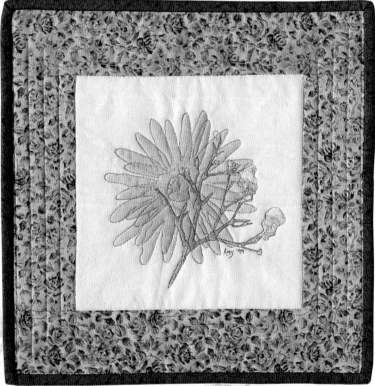

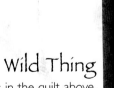

11" x 11". Pounded, machine pieced, and quilted by Amy Sandrin.

Colorado Christmas

In the back of my mind, I didn't think pounding a poinsettia would turn out, but it worked beautifully. The texture of the veins in the leaves and petals is very pronounced, and the colors are brilliant. The centers seemed to need something, however. After studying a real poinsettia, Ann perfectly matched the centers using silk-ribbon embroidery and beadwork to reproduce the stamen.

30" x 29". Pounded, machine pieced, and quilted by Amy Sandrin. Beadwork by Ann Frischkorn.

O' Christmas Tree

I pounded this piece using the branches of a dwarf Alberta spruce from my mother's backyard. I purposely positioned them so they would take on the shape of a Christmas tree. I then glued on colored sequins as ornaments using Aleene's Jewel-It™ Embellishing Glue.

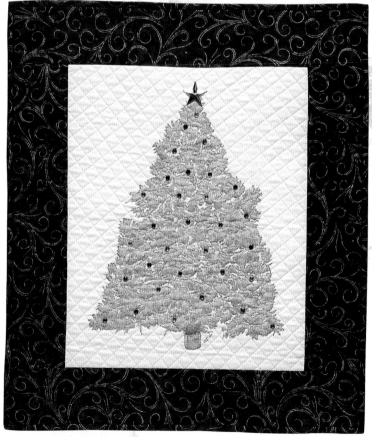

22¼" x 25¾". Pounded, machine pieced, and quilted by Ann Frischkorn. From the collection of Linda Goldsberry.

A Penny For Your Thoughts

This quilt honors the memory of fellow quilter, Penny Taylor, who lost her battle with breast cancer in the fall of 1999. "Quilt for a Cure" fabric, designed by Bonnie Benn Stratton, was used in the border. Special thanks to Bonnie for sending the "Quilt for a Cure" pin, which rests in the upper left corner. I used delphiniums and misty blue in this quilt.

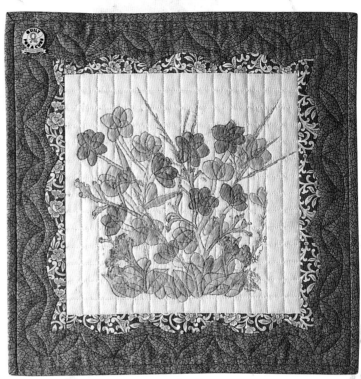

15" x 15". Pounded, machine pieced, appliquéd, and quilted by Ann Frischkorn.

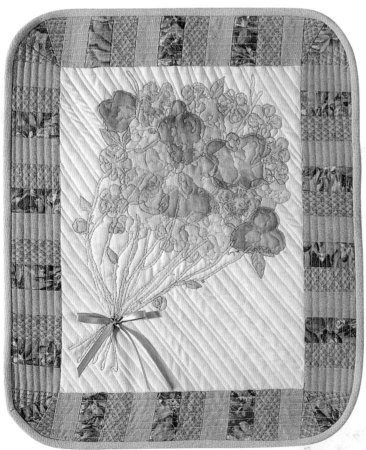

14¼" x 17". Pounded, machine pieced, and quilted by Amy Sandrin. From the collection of Maggi Landry.

Sugar and Spice

This bouquet celebrates the birth of a baby girl. I used a variety of pink fabrics in the border and "tied" the stems together with a pale green ribbon. The flowers I used in this quilt include begonias, moss rose, and geraniums.

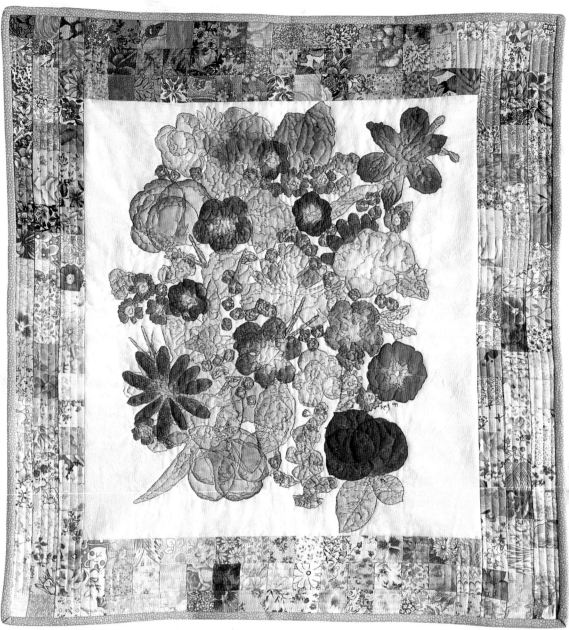

21¼" × 22¼". Pounded, machine pieced, and quilted by Amy Sandrin.

Paint Me a Garden

I have always loved watercolor quilts. It seemed only natural to combine the method with flower pounding. It took me five hours to pound the flowers, five hours to outline the petals with black permanent marker, and who knows how long to cut out all the 1½-inch squares. The result was well worth every minute. This one hangs proudly in my living room. The flowers I used in this quilt include roses, carnations, liatris, alstroemeria, gerbera daisies, primrose, and tulips.

Moody Blue

For this quilt, I simply pounded a large purple carnation, using misty blue as an accent flower. I started by pounding the outer layer first, then let it dry before moving to the next round. I echo quilted around the flower and simply straight-line quilted the border.

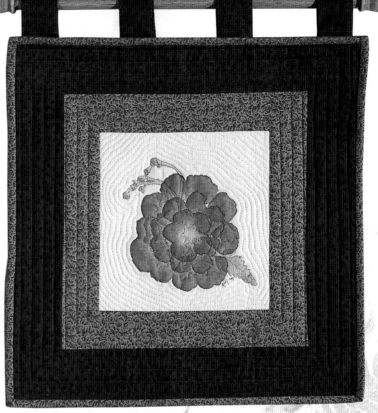

14½" × 14½". Pounded, machine pieced, and quilted by Amy Sandrin.

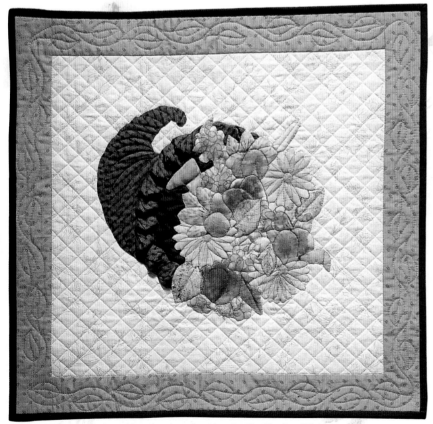

21½" × 20½". Pounded, machine pieced, appliquéd, and quilted by Ann Frischkorn.

Bountiful Harvest

I had been toying with the idea of pounding a "basket" of flowers, but could not decide on the type of basket. Then, during Thanksgiving it hit me! I would pound a cornucopia filled with seasonal flowers. First, I designed and constructed the cornucopia. Next, I used a separate piece of muslin, roughly in the shape of the inside of the cornucopia, to pound a variety of seasonal flowers. I then appliquéd the pounded muslin to fit inside and over the cornucopia. I used alstroemeria, roses, tulips, and bouvardia. To get a 3-D effect, I stuffed the flowers with batting before appliquéing them in place. The rim of the basket was made by twisting two tubes of fabric together.

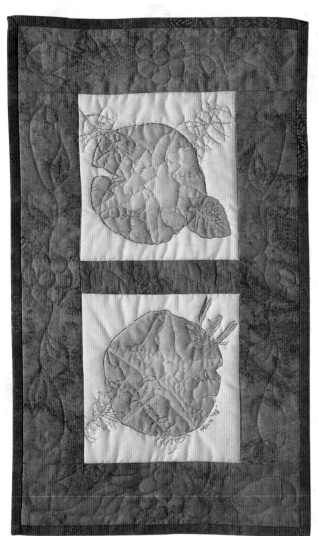

9¾" x 16". Pounded, machine pieced, and quilted by Ann Frischkorn. From the collection of Mary Frischkorn.

Paradise Found

I was driving my daughter, Kate, to preschool when I spotted a telephone pole covered with beautiful morning glories. Without hesitating, I drove around the block and stopped to pick some. Thank goodness the house was still under construction and no one lived there (though I'm not altogether sure that would have stopped me). I revisited the site many times throughout the summer. The flower was a bright blue when picked, and turned lavender when pounded.

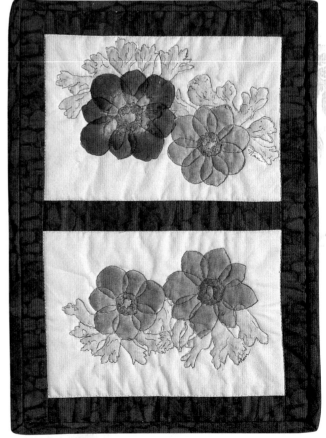

They Were Anemones, but Now They're Friends

These anemones were purchased in the middle of winter from a florist. Flower pounding doesn't have to be a summer-only sport!

10" x 14". Pounded, machine pieced, and quilted by Ann Frischkorn.

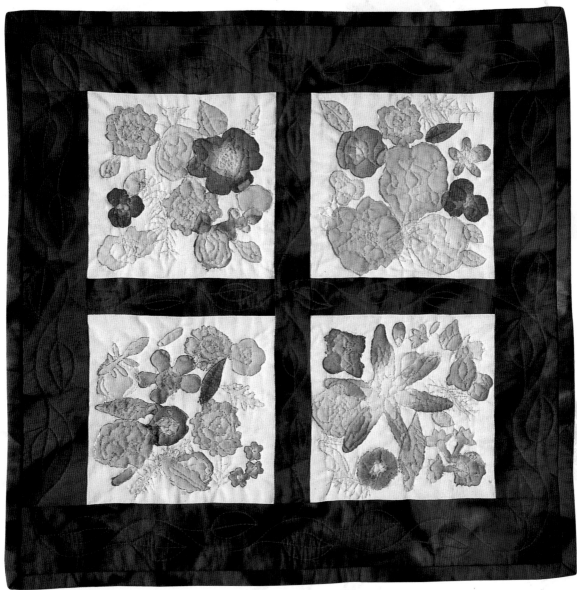

16½" x 16½". Pounded, machine pieced, and quilted by Ann Frischkorn.

Along for the Adventure

This quilt was created during a weekend of non-stop flower pounding. The one flower in this quilt that stands out in my memory is the purple and yellow day lily in the lower right corner. We took a break from pounding to go to our favorite fabric store. When we were driving away, Amy yelled, "Ann, stop the car. Look at that flower!" I pulled into the closest parking space and, with Amy and the kids serving as lookouts, I picked a few. It was a bright orange flower. I was very surprised when it pounded out purple. Other flowers I used in this quilt include begonias, petunias, geraniums, and pincushion flowers.

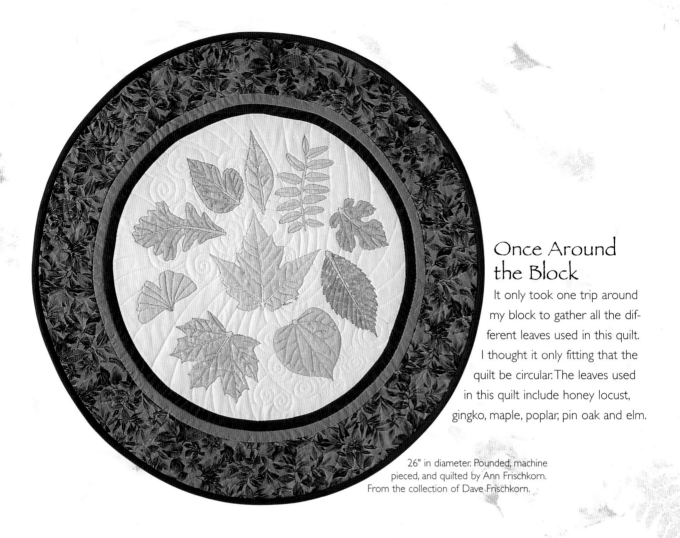

Once Around the Block

It only took one trip around my block to gather all the different leaves used in this quilt. I thought it only fitting that the quilt be circular. The leaves used in this quilt include honey locust, gingko, maple, poplar, pin oak and elm.

26" in diameter. Pounded, machine pieced, and quilted by Ann Frischkorn. From the collection of Dave Frischkorn.

On the Wings of a Dove

Doves are the symbol of love and seemed like the perfect choice to capture the memory of a wedding. I wanted something elegant for the border, so I used an off-white silk brocade. The flowers I used in this quilt include carnations, roses, alstroemeria, and liatris.

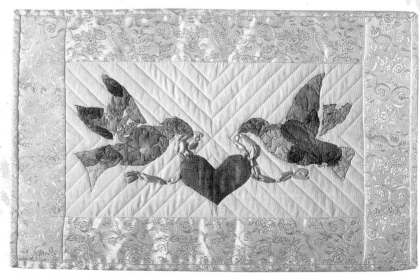

21¼" x 13½". Pounded, machine pieced, and quilted by Amy Sandrin.

Colorado Gold Rush

Orange gerbera daisies and orange primroses, along with a bit of a plant called misty blue were used in this quilt. When it was finished, it reminded me of the gold rush from the old days.

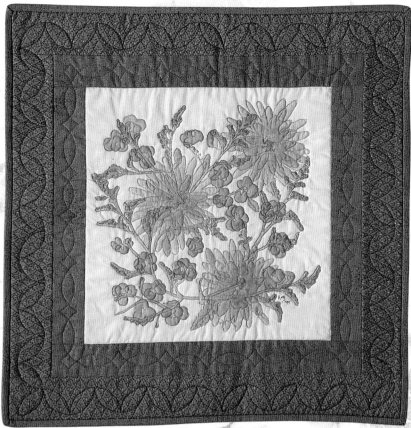

19" x 19". Pounded, machine pieced, and quilted by Amy Sandrin. From the collection of Lynda Sue Cooper.

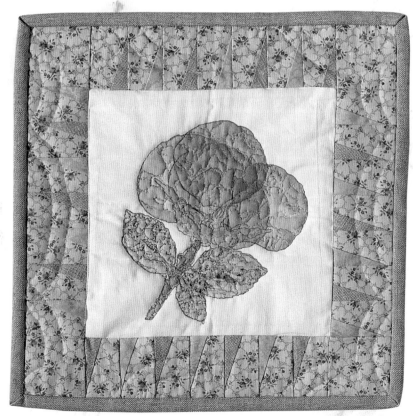

11" x 11". Pounded, machine pieced, and quilted by Amy Sandrin.

Forever Roses

A simple pink rose was the only flower pounded on this quilt. Part of the rose was a bright pink, which matched the spikes in the border. When I heat set the colors, I had my iron set too high, which scorched the pounding and forever changed the colors. Fortunately, it further enhanced the antique feel, but this was a good lesson about temperature control.

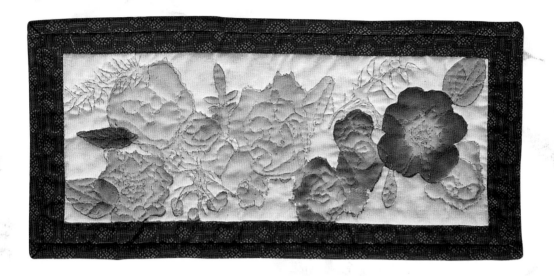

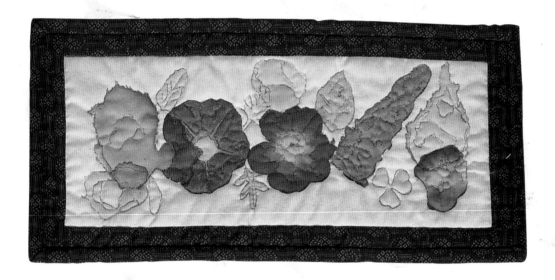

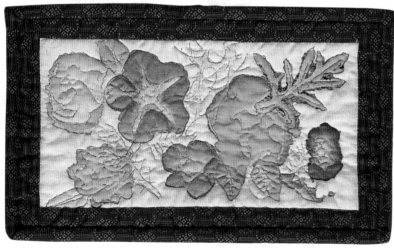

Etched in Memory

I pounded this series of quilts using a wide variety of flowers such as petunias, begonias, wild roses, and impatiens. I picked most of them from my own backyard.

11½" × 5½", 11½" × 5½", and 9" × 5½". Pounded, machine pieced, and quilted by Ann Frischkorn.

SUBSTITUTION BLUES

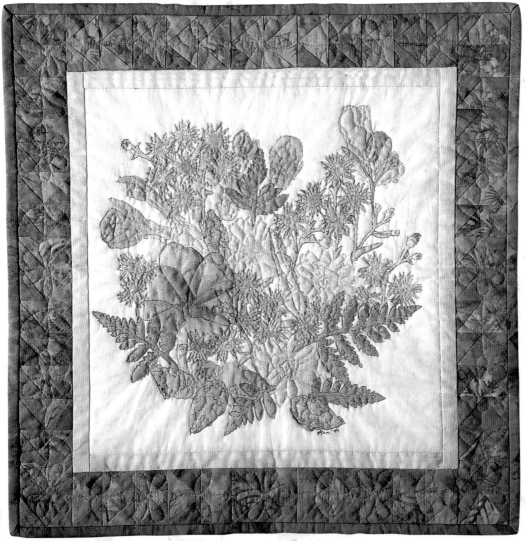

Finished size: 20½" × 20½". Pounded, machine pieced, and quilted by Ann Frischkorn.
From the collection of Stephanie Keate.

My next-door neighbor, Stephanie, received this bouquet of flowers in appreciation for substituting at our local elementary school for a week. Knowing that I was an avid flower pounder, Stephanie gave me the bouquet. In return, I surprised Stephanie by giving her the finished quilt.

Substitution Blues

MATERIALS

- One piece of treated cotton muslin 14½" x 14½"
- ⅛ yard of fabric for first border
- ⅜ yard of fabric for Flying Geese
- ½ yard of fabric for background of Flying Geese and binding
- 22" square of fabric for backing
- 22" square of batting
- Flowers: Astors, Gladiolas, Daisies, and Roses

CUTTING

From the border fabric, cut two 1"-wide strips, then cut into two 14½" lengths plus two 15½" lengths.

From the fabric for the Flying Geese, cut three 3½"- wide strips.

From the fabric for the Flying Geese background, cut three 2½"- wide strips.

From the binding fabric, cut three 2¼"- wide strips.

DIRECTIONS

Starting in the center of the muslin, pound your first flower.

Working around your center flower, add more flowers. Try to keep your color placement balanced. Stand back from your work often to see where blank spaces are. Fill in needed areas with greenery. Using a permanent, fine-line fabric marker, outline all the petals and leaves.

Sew one 14½" x 1" strip to the top and bottom of the quilt using a ¼" seam allowance. Press seams toward the border. Sew one 15½" x 1" strip to each side of the quilt. Press seams toward the border.

Make fourteen (14) blocks (four Flying Geese in each block) for the border using the pattern on the next page.

PAPER PIECING

Make a copy of the pattern for each block you are going to sew.

This can be done on a copy machine or by tracing onto tracing paper. Cut off the excess paper, leaving about a ½" around each pattern.

Get the sewing machine ready by using a 90/14 needle and setting the stitch length to 18 to 20 stitches per inch. This makes the paper easier to remove.

Starting with pattern piece number one, place the fabric on the back of the pattern so that the wrong side of the fabric is against the un-printed side of the paper. Hold it up to the light to make sure all edges of pattern piece number one are covered by the fabric. Pin into place.

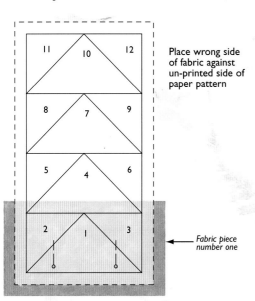

Place wrong side of fabric against un-printed side of paper pattern

← *Fabric piece number one*

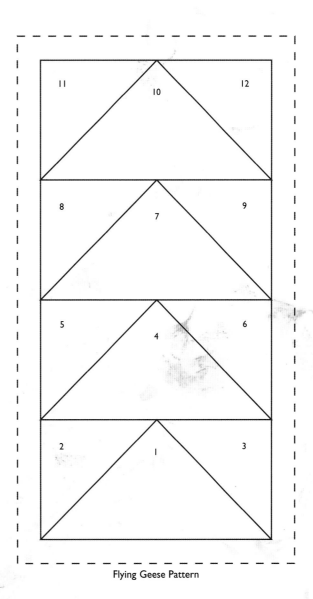

Flying Geese Pattern

My Notes:

Take the fabric for pattern piece number two, place it right sides together over piece number one. Make sure the raw edge of your fabric extends past the sewing line on both sides.

Hold or pin in place and carefully slide under the presser foot, with the printed side of the paper pattern piece face up. The fabric will be to the back. Sew on the line between pieces one and two starting about one stitch before the beginning of the line and extending one stitch past.

Clip the thread and remove from machine. Fold paper away from seam and trim the seam to an eighth of an inch. Press.

Continue in the same manner for each piece until complete.

When the blocks are all made, sew together two rows of three blocks each. Sew a row to the top of the quilt with the arrows pointing to the left. Sew a row to the bottom of the quilt with the arrows pointing to the right. Press seams toward inner border.

With the remaining blocks make two rows of four blocks each. Sew a row to the left side of the quilt with the arrows pointing down. Sew a row to the right side of the quilt with the arrows pointing up. Press seams toward the inner border.

See page 70 for layering and basting instructions. When layers are all pinned together, quilt as desired.

See page 71 for binding instructions.

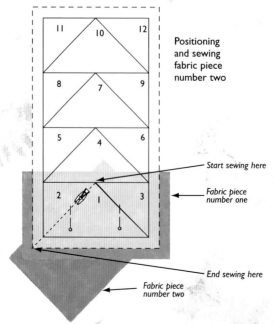

Positioning and sewing fabric piece number two

Start sewing here

Fabric piece number one

End sewing here

Fabric piece number two

CUP O' JOE

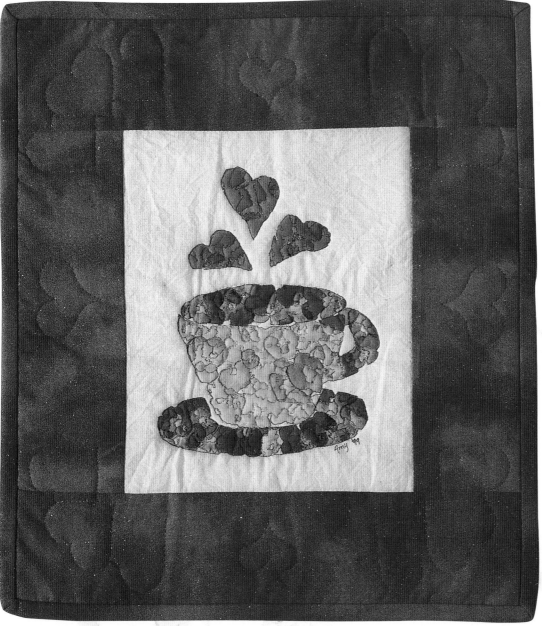

Finished size: 11" × 12¼". Pounded, machine pieced, and quilted by Amy Sandrin.
From the collection of Tammy Landis.

I made this quilt for my next-door neighbor because we always go for coffee together. To gain access to the flowers in her garden, I gave her this quilt.

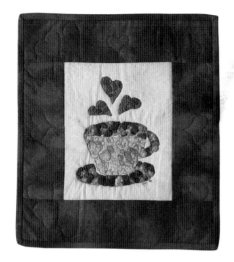

Cup o' Joe

MATERIALS

- One piece of treated cotton muslin, 6½" x 7¾"
- ⅜ yard of fabric for border and binding
- Scrap of fabric for backing, at least 13" x 15"
- Scrap of batting, at least 13" x 15"
- One sheet of template plastic
- Flowers: Johnny-jump-ups and Dianthus

CUTTING

From the border fabric, cut one 2¾"-wide strip. Cut into two 7¾" lengths and two 11" lengths.

From the binding fabric, cut two 2¼"-wide strips.

DIRECTIONS

Copy or trace the coffee cup pattern onto a piece of template plastic for the stencil. Cut out the shaded areas. Center the stencil over the scrap of muslin and tape it down. Working on the middle section of the coffee cup, choose a light-colored flower to pound. I used yellow Johnny-jump-ups.

When this section is completely filled in, you will need to reposition the stencil so the saucer meets the cup. Tape the stencil in place.

Use a darker-colored flower to pound the saucer; I chose purple Johnny-jump-ups for mine. When this section is completely filled in, reposition the stencil downward so the opening of the cup meets the cup itself. Tape it down, and again use the same dark-colored flower used for the saucer. You will need to move the stencil slightly to the left to finish pounding the handle on the mug so it "attaches" to the cup. Keep the stencil in place for the hearts. Choose a flower that will pound red or pink. I used dianthus.

Using a permanent, fine-line fabric marker, outline the flowers. Sew one 7¾" x 2¾" border strip to each side using a ¼" seam allowance. Press seams toward the border. Sew the remaining border strips to the top and bottom of the quilt. Press toward border.

See page 70 for layering and basting instructions. When layers are all pinned together, quilt as desired. I quilted heart shapes around my border to follow the pattern of the "steam" hearts.

See page 71 for binding instructions.

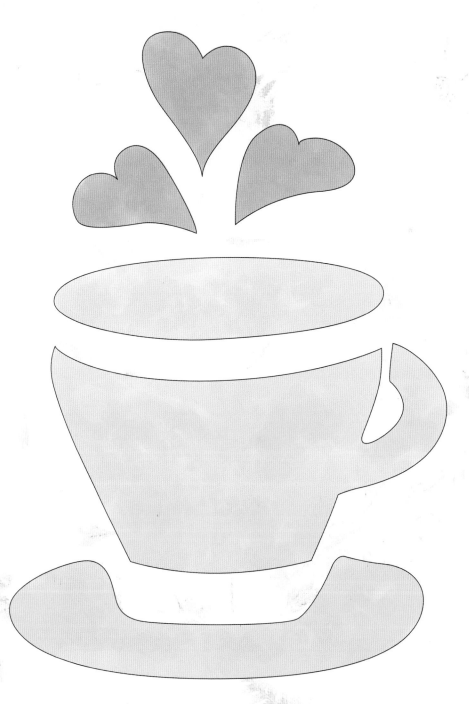

GOOD CHI

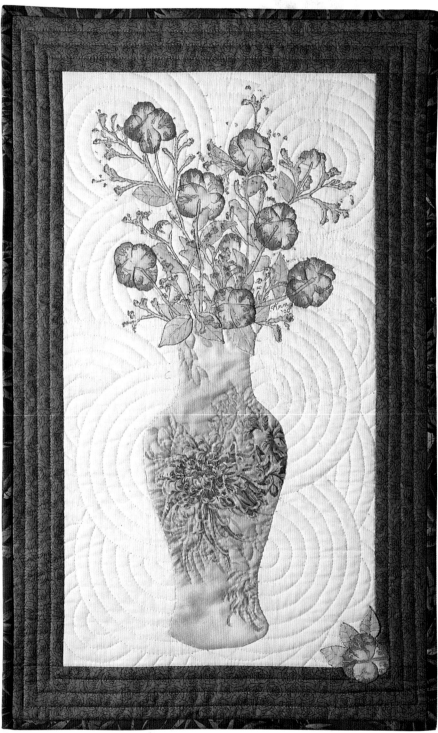

Finished size: 15¾" × 25". Pounded, machine pieced, appliquéd, and quilted by Ann Frischkorn.

Flowers are considered good Feng Shui, and it brings good fortune to display them in artwork.

Good Chi

MATERIALS

- Piece of treated cotton muslin 11¾" x 21"
- Treated cotton muslin scraps for appliquéd pounded flowers and leaves
- ¼ yard of fabric for border
- ¼ yard of fabric for binding
- ½ yard of fabric for backing (18" x 28")
- ½ yard of batting (18" x 28")
- ¼ yard of oriental fabric for the vase (a large print works best).
- We suggest approximately ½ yard, depending on print and orientation
- Freezer paper
- Piece of colored paper
- Flowers: Carnations and Misty Blue

CUTTING

From the border fabric, cut two 2 ½"-wide strips. Cut each strip into a 21" length and a 15¾" length.

From the binding fabric, cut three 2¼"-wide strips.

DIRECTIONS

Enlarge the pattern on page 57 131%, trace the vase pattern onto colored paper, and cut it out.

Position the paper vase about one inch from the bottom of the muslin, centered on both sides. Pin in place. This will help you with the placement of your pounded flowers. You want them to look like they are coming out of the vase.

Pound the flowers of your choice above the paper vase. I used carnations that were white with red tips (they pounded purple), and used misty blue as my filler. Using the scrap muslin, pound two to three flowers and six to eight leaves. These will be appliquéd over the top of the vase once it is sewn to the quilt. One flower will be placed in the bottom right corner of the quilt.

My Notes:

Trace the vase pattern onto the dull side of the freezer paper and cut it out. Use the hole left by the vase to audition fabric.

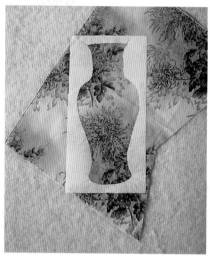

Move the freezer paper around on the fabric until you find the perfect spot for your vase.

When you are happy with the view through your vase window, place the freezer paper vase back into the hole, shiny side down. Take the outside away and iron the vase in place. Cut the material around the vase, adding about ⅛" to turn under for appliqué. Appliqué the vase in place.

Cut out the extra flowers and leaves, again adding ⅛" to turn under. Move the flowers and the leaves around over the lip of the vase until you find a pleasing arrangement, then pin in place and appliqué. Appliqué the final flowers and leaves in the lower right hand corner after the borders are added.

Using a permanent, fine-line fabric marker, outline the flowers and leaves.

Sew one 21" strip to each side of the quilt using a ¼" seam allowance. Press seams toward the border. Sew the remaining border strips to the top and bottom of quilt. Press toward the border.

See page 70 for layering and basting instructions. When layers are all pinned together, quilt as desired. I used a circular pattern, which gives the quilt movement.

See page 71 for binding instructions.

Enlarge 131%

My Notes:

ROSE BUD

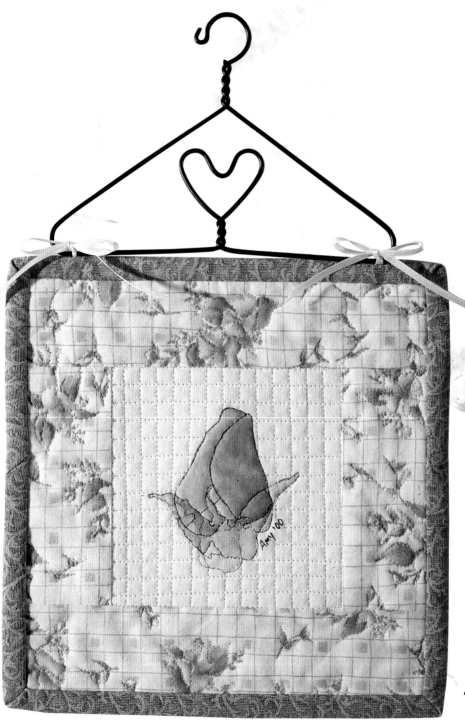

Sweet and simple, this rose bud was fast and fun to make.

Finished size: 7½" × 7½". Pounded, machine pieced, and quilted by Amy Sandrin.

Rose Bud

MATERIALS

- One piece of treated cotton muslin, 4½" x 4½"
- ⅛ yard of fabric for border
- ⅛ yard of fabric for binding
- 10" square piece of fabric for backing
- 10" square piece of batting
- ⅔ yard ⅛"- wide ribbon
- Quilt hanger
- Flowers: Rose petals

CUTTING

From the border fabric, cut one 2"-wide strip. Then cut two 4½" lengths and two 7½" lengths.

From the binding fabric, cut one 2 ¼"-wide strip.

DIRECTIONS

Take a rose petal and fold it in half lengthwise. Place on center of the muslin, tape it down, and pound. Take off the tape and let the fabric dry. Take another petal, fold it in half lengthwise again, and overlap the first pounded petal so it takes the shape of a rose bud. Tape and pound. When this is dry, take leaves and overlap the petals as though they are coming up from the base. Tape and pound.

Using a permanent, fine-line fabric marker, outline the rose and leaves.

Sew one 4½" x 2" border strip to each side using a ¼" seam allowance. Press seams toward the border. Sew the remaining border strips to the top and bottom of the quilt. Press seams toward the border.

See page 70 for layering and batting instructions. When layers are all pinned together, quilt as desired.

See page 71 for binding instructions.

Cut two 12" strips of ⅛"-wide ribbon. Tie each in a bow around the bottom of the left and right side of the hanger. Tack the bottom of each bow to the quilt binding. Trim bow tails to desired length.

MELODY OF SPRING

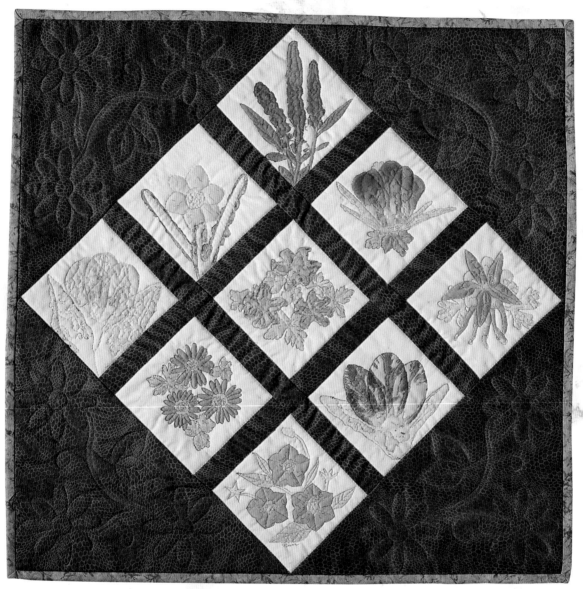

Finished size: 22½" × 22½".
Pounded, machine pieced, and quilted by Ann Frischkorn.
From the collection of Mary Jo Boelkens.

I selected a variety of spring flowers, such as daffodils, crocus, tulips, columbine, hyacinth, daisies, liatris, and campanulas, then set the blocks on point.

Melody of Spring

MATERIALS

- Nine 5" squares of treated cotton muslin
- ½ yard of fabric for borders and sashing
- ¼ yard of fabric for binding
- ¾ yard of fabric for backing, or a 25" square piece
- ¾ yard of batting, or a 25" square piece of batting
- Flowers: Liatris, Daffodils, Crocus, Tulips, Hyacinth, Columbine, Daisies, and Campanula.

CUTTING

From the border fabric, cut two 11⅞" squares. Cut these squares in half diagonally.

From the border fabric, cut two 1½"-wide strips. Cut into six 5" lengths and two 16" lengths for the sashing.

From the binding fabric, cut three 2¼"-wide strips.

DIRECTIONS

Pound various springtime flowers in the center of each 5" block of muslin. Remember to pound these on-point, i.e. have a point of each square on the exact top and bottom instead of horizontal. Using a permanent, fine-line fabric marker, outline the flowers and leaves.

On-point block

Layout of Melody of Spring

Arrange the squares in the desired order. Sew the first row of three together with a 5" x 1½" sashing strip between them.

Sew the other two rows in the same fashion. Sew the three completed rows together with the long 16" x 1½" sashing strip between them.

Take one triangle border piece and fold it in half at the base to find the exact center. Fold one side of

the quilt in half to get the exact center. Pin these right sides together, matching the centers. Sew the seams using a ¼" seam allowance. Press seams toward triangles. Repeat this procedure for the remaining three sides.

See page 70 for layering and basting instructions. When layers are all pinned together, quilt as desired.

See page 71 for binding instructions.

COUNTRY CHRISTMAS

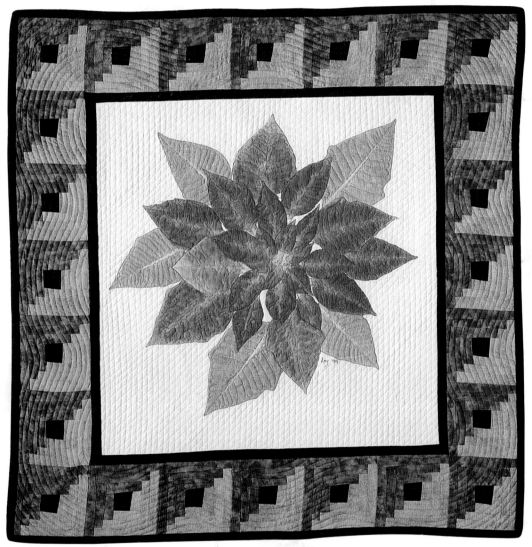

Finished size: 28½" × 28½".
Pounded, machine pieced, and quilted by Amy Sandrin.
From the collection of Debbie Peters.

I had so much fun pounding my first poinsettia I knew I had to pound another. This time I decided to go for a country feel, I paper-pieced crazy Log Cabin blocks in the border. A special thanks to the gals at High Prairie Quilts in Parker, Colorado, who suggested the hint of black in the border that added that extra spark the quilt needed.

Country Christmas

MATERIALS

- One 18½" x 18½" piece of treated cotton muslin
- ½ yard of black fabric for inner border, center of blocks and binding
- ¾ yard dark green fabric for blocks
- ¾ yard medium green fabric for blocks
- One yard fabric for backing (32" x 32")
- One yard batting (32" x 32")
- Flowers: Poinsettia

CUTTING

From the black fabric, cut two 1½"-wide strips. Cut into two 18½" lengths and two 20½" lengths for the inner border. From same fabric, cut one 1½"- wide strip for center of blocks.

Cut three 2¼"-wide strips for the binding.

From each of the green fabrics, cut twelve 1½"-wide strips. As you are sewing, cut more if needed.

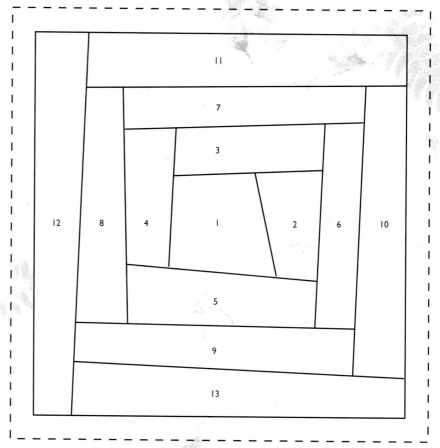

Log Cabin pattern

DIRECTIONS

Starting in the center of the muslin, pound poinsettia petals, arranging them in a circular pattern. Let fabric dry between each petal. Keep working outward toward the edges adding more petals and leaves as you go.

Using a permanent, fine-line fabric marker, outline all the petals and leaves.

Sew the 18½" x 1½" black strips to each side of quilt, using a ¼" seam allowance. Press seams toward the border. Sew the 20½" x 1½" strips to the top and bottom of the quilt. Press seams toward the border.

PAPER PIECING

Make a copy of the pattern for each block you are going to sew. This can be done on a copy machine or by tracing onto tracing paper. Cut off the excess paper, leaving about a ½" border around each pattern.

Get the sewing machine ready by using a 90/14 needle and setting the stitch length to 18 to 20 stitches per inch. This makes the paper easier to remove.

Starting with pattern piece number one, place the fabric on the back of the pattern so that the wrong side of the fabric is against the unprinted side of the paper. Hold it up to the light to make sure all edges of pattern piece number one are covered by the fabric. Pin into place.

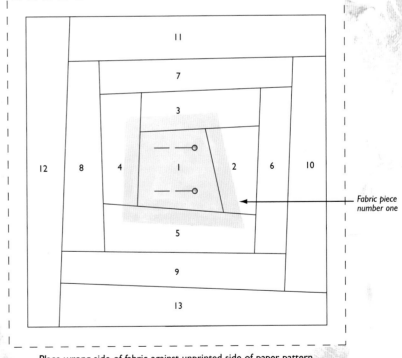

Fabric piece number one

Place wrong side of fabric against unprinted side of paper pattern.

My Notes:

Take the fabric for pattern piece number two and place it, right sides together, over piece number one. Make sure the raw edge of your fabric extends past the sewing line on both sides.

Hold or pin in place and carefully slide under the presser foot, with the printed side of the pattern piece face up. The fabric will be to the back. Sew on the line between pieces one and two, starting about one stitch before the beginning of the line and extending one stitch past.

Clip the thread and remove from machine. Fold paper away from the seam and trim the seam to an eighth of an inch. Press.

Continue on in the same manner for each piece until complete.

When the blocks are all made, sew together two rows of five blocks each. Sew a row to each side of the quilt. With the remaining blocks, make two rows of seven blocks each and sew to the top and bottom of the quilt.

See page 70 for layering and basting instructions. When layers are all pinned together, quilt as desired.

See page 71 for binding instructions.

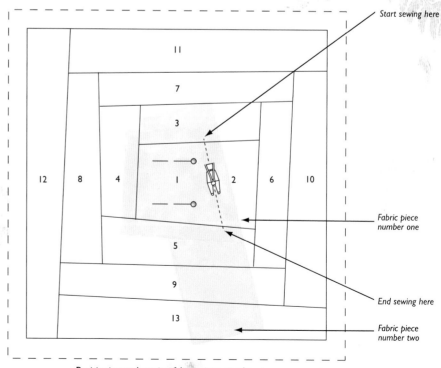

Positioning and sewing fabric piece number two

COOL TREATS

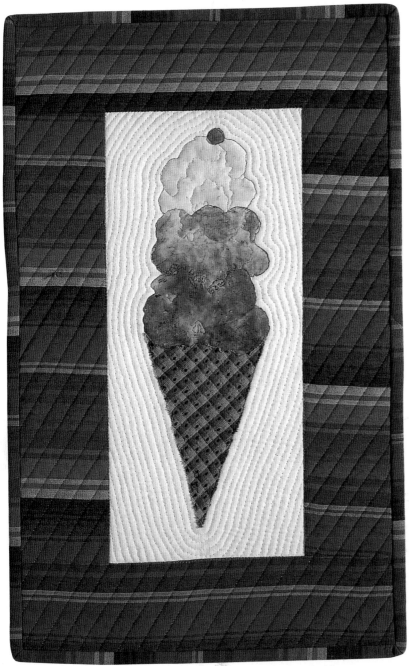

Finished size: 11" × 17½". Pounded, machine pieced, and quilted by Amy Sandrin.

Three different colored carnations, pink, red, and purple, were used to pound the ice cream scoops. For the cherry, I cut a round shape out of a red gerbera daisy (test first, sometimes they pound brown). The brown plaid fabric made an excellent waffle cone and the border fabric reminded me of an ice cream parlor.

Cool Treats

MATERIALS

- One 6" x 12½" piece of treated cotton muslin
- ⅜ yard of fabric for borders and binding
- 5" x 7" scrap of fabric for cone
- 13" x 20" piece of fabric for backing
- 13" x 20" piece of batting
- 5" x 7" piece of fusible web
- Flowers: Pink, Red and Purple Carnations, and a Gerbera Daisy

CUTTING

For the borders, cut two 3"-wide strips. Cut into two 11" lengths and two 12½" lengths. From the same fabric, cut two 2¼"-wide strips for the binding.

DIRECTIONS

Starting just slightly higher than the center of the muslin, pound your first ice cream scoop using the carnation color of your choice. Move up to the next scoop, using a different colored carnation. For the third scoop, choose yet another color of carnation. For the cherry on top, select a flower that pounds red. You might have to cut the shape of the cherry from a petal.

Test the color on a piece of scrap fabric first, as some red flowers do not pound red. Using a permanent, fine-line fabric marker, outline the scoops of ice cream.

Using template on the next page, trace the cone shape onto 5" x 7" piece of fusible web. Iron onto the piece of cone fabric. Cut out the shape. You may have to adjust the "scallop" of the top of the cone to match the shape of your bottom ice cream scoop. Iron into place following the directions that come with the fusible transfer web you are using. Finish with satin stitching if desired.

Sew the two 12½" strips of border fabric to either side of the muslin. Press seams toward the border. Sew the remaining border strips to the top and bottom of the quilt, press seams toward the border.

See page 70 for layering and basting instructions. When layers are all pinned together, quilt as desired.

See page 71 for binding instructions.

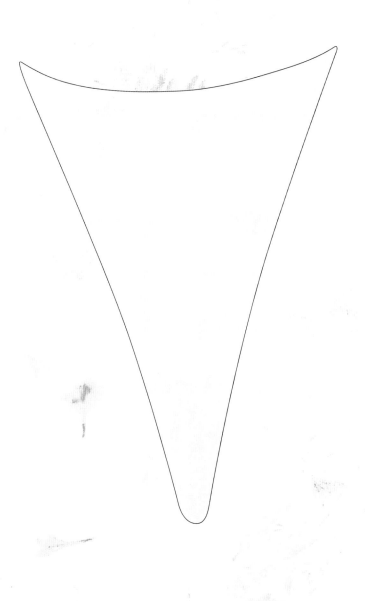

FINISHING THE QUILT

BORDERS

When choosing a border, it is best to keep it on the simple side. A busy border will draw attention away from the focal point: the pounded flowers.

Layering and Pin Basting Your Quilt

Take the backing fabric, place it right side down on a flat surface such as a table or the floor. Keep in mind that the pins will scratch the surface, so don't use a good table. If the quilt is small enough, you can place it on your rotary cutting mat.

Tape the fabric to the surface on all four sides.

Once all four sides are taped down, starting at one piece of tape and working in a circular fashion, lift up the tape and pull the fabric to straighten it, pressing the tape back down as you go along. Do this all the way around the quilt until the fabric is smooth and taut.

Next, lay the batting on top of the backing fabric. Smooth it out with your hands, making sure there are no puckers. Lay the quilt top over the batting, making sure it is centered over all the rest. Smooth it out also, alleviating all puckers.

Starting in the center, begin pinning all three layers together. Place pins approximately three inches apart working out to the ends. When you finish pinning, remove the tape. You are now ready to quilt.

Use a crochet hook to help close the safety pins when pin basting. Pull the pin point with the hook and close. Not only will you get done faster, you won't have sore fingers.

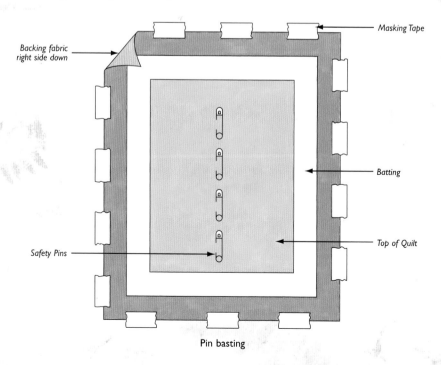

Masking Tape

Backing fabric right side down

Batting

Top of Quilt

Safety Pins

Pin basting

THREAD

When quilting the pounded flower area, invisible nylon thread is a must. Colored thread on the flowers would be distracting and take away from the natural beauty. Though many quilters experience problems using invisible nylon thread, it is often the quality of the product that causes the trouble. You can avoid this by using only a high quality invisible thread such as Sew Art International™ or YLI Wonder Thread™.

Another way to avoid problems with invisible nylon thread is to always use 50 weight, 3-ply, 100% cotton sewing thread in the bobbin. Use any color. If the tension is adjusted correctly, it won't show on the top. Don't be afraid to adjust your tension, and always practice on a scrap quilt sandwich first to make sure you are getting the exact results you want.

QUILTING

Marking the Quilt Pattern

Since these quilts can't be thrown in the wash when they are completed, it is best to avoid any kind of marking pen, pencil, or chalk. Masking tape can be used to mark gridline quilting.

For more complicated patterns, draw on tissue paper and pin it to the quilt. Tissue paper tears away easily and doesn't leave marks.

Binding Instructions

Strips for binding should already be cut from the pattern instructions. The first step in binding is to sew all the strips together to form one continuous strip. Use a diagonal seam to avoid bulk.

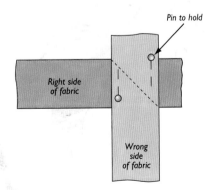

Sewing binding on the bias

Trim off excess fabric, leaving a ¼" seam. Press seam.

Fold entire strip in half lengthwise, wrong sides together, and press.

On the front of the quilt top, beginning in the center of one side, place the raw edge of the binding strip even with the raw edge of the quilt. Using a ¼" seam allowance, start sewing about two inches from the beginning of the binding. Sew until you get a ¼" from the corner. Back tack, clip threads, and remove quilt from sewing machine.

Flip and diagonally fold the binding strip upwards.

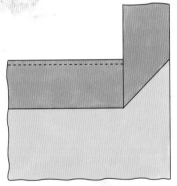

Fold the binding strip upwards.

Keep the right edge of the binding even with the right edge of the quilt.

Hold the fold in place with one hand. With the other hand bring the strip back down, keeping the top and right edges even with the quilt.

Hold the fold in place with one hand. With the other hand bring the strip back down.

Starting at the top of the fold, stitch all the way to the next corner, stopping ¼" from the edge. Repeat the above procedure for each remaining corner.

Stop sewing about three to four inches from where you began. Back tack, clip your threads, and remove the quilt from machine. There should be more than enough strip left on both ends to overlap.

Make a diagonal cut on half of the strip. Make a second diagonal cut going in the opposite direction.

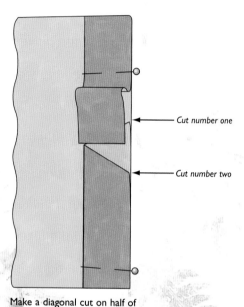

Cut number one

Cut number two

Make a diagonal cut on half of the strip. Make a second diagonal cut going in the opposite direction.

Fold the raw diagonal edge under. A small corner will hang over the edge of the quilt. Trim this off. Slip the raw-edged binding inside the folded binding. Pin in place and sew the rest of the binding down.

LABELS

When you are finished with your quilts, don't forget the all-important label on the back. This can be as brief as listing your name, state, and date of completion. If your quilt has a story, this is a good place to include it.

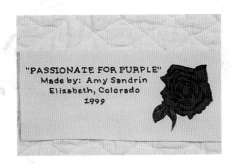

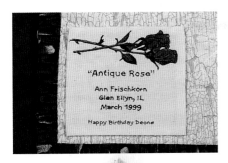

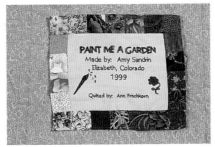

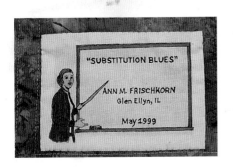

ABOUT THE AUTHORS

Amy Sandrin and Ann Frischkorn

Amy Sandrin and Ann Frischkorn are identical twins who, despite the thousand miles separating them, still manage to converse almost daily.

Amy is an award-winning romance author who dabbles in quilting. Ann is an award-winning quilter who dabbles in writing.

In one of their many conversations, they joked about combining both their talents and collaborating on a quilting book together.

The joke turned to reality when they discovered the flower pounding process and knew it was their destiny to share this technique with the quilting and crafting world.

Amy lives in Colorado with her husband, son, and two whimsical cats.

Ann lives in Illinois with her husband, two cats, and three whimsical kids.

FLOWER INDEX

Note: The flowers included in this index are a selection of flowers used in the quilts throughout the book.

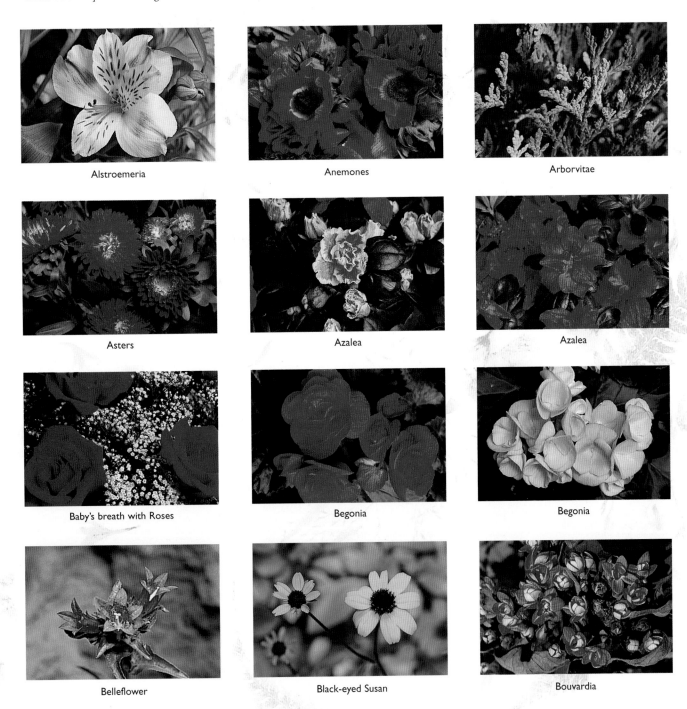

Alstroemeria	Anemones	Arborvitae
Asters	Azalea	Azalea
Baby's breath with Roses	Begonia	Begonia
Belleflower	Black-eyed Susan	Bouvardia

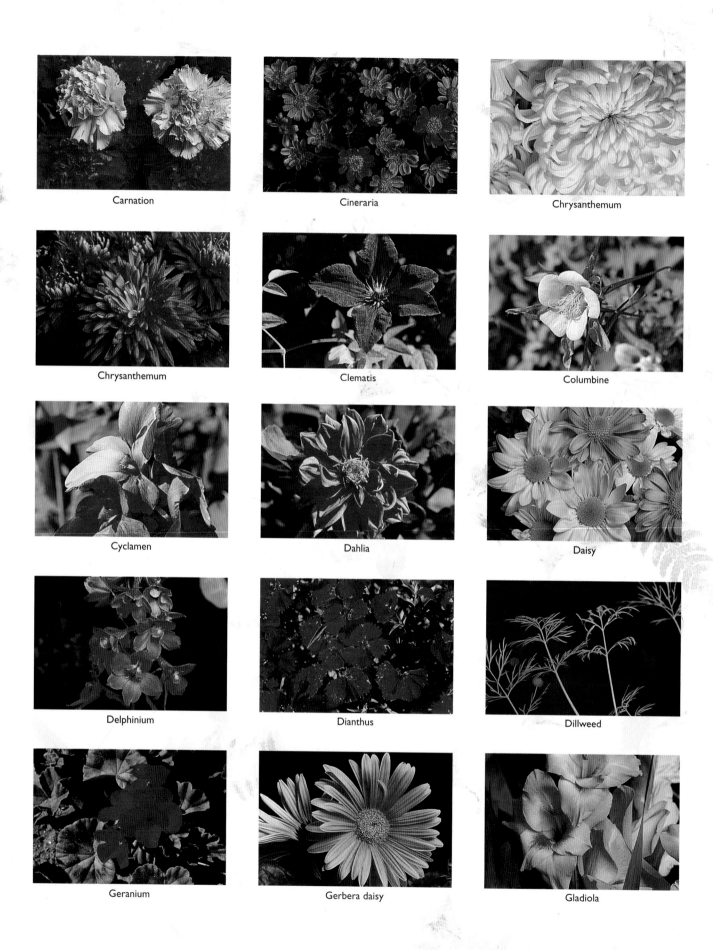

Carnation

Cineraria

Chrysanthemum

Chrysanthemum

Clematis

Columbine

Cyclamen

Dahlia

Daisy

Delphinium

Dianthus

Dillweed

Geranium

Gerbera daisy

Gladiola

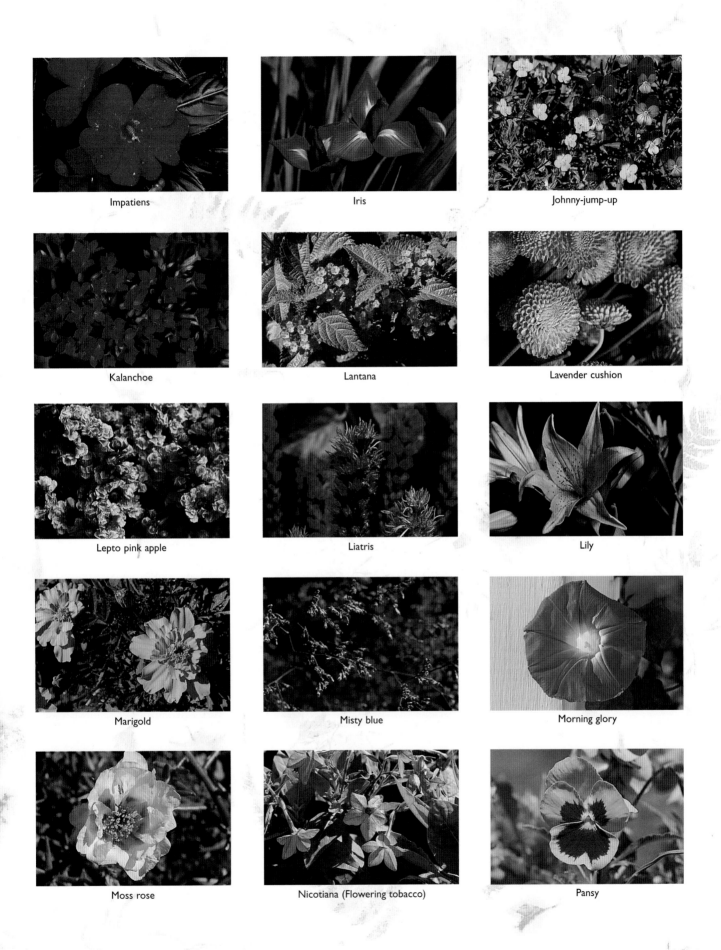

Impatiens

Iris

Johnny-jump-up

Kalanchoe

Lantana

Lavender cushion

Lepto pink apple

Liatris

Lily

Marigold

Misty blue

Morning glory

Moss rose

Nicotiana (Flowering tobacco)

Pansy

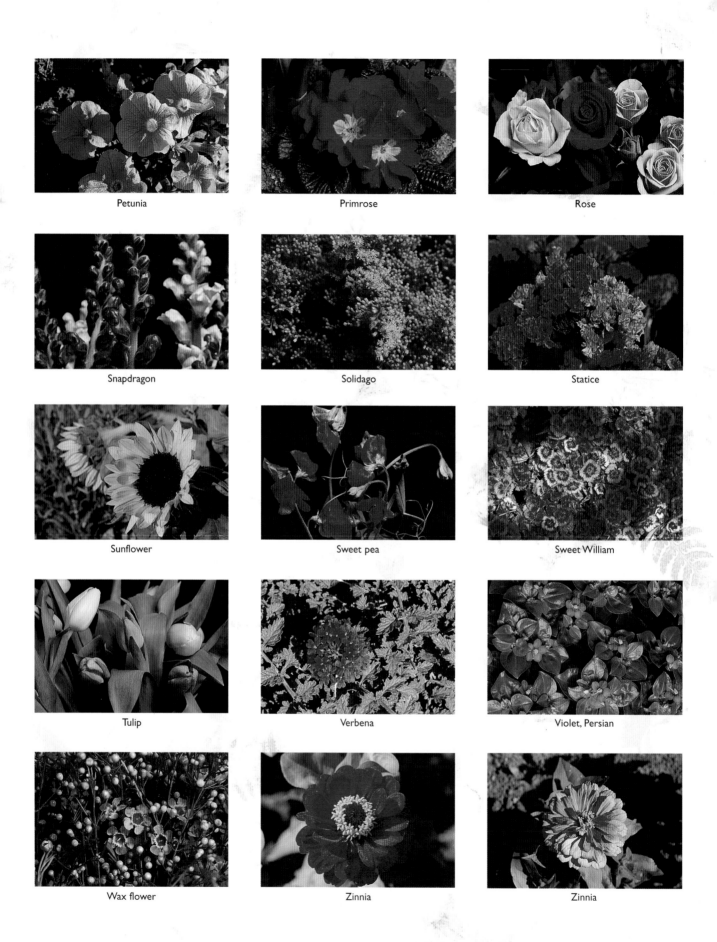

Petunia

Primrose

Rose

Snapdragon

Solidago

Statice

Sunflower

Sweet pea

Sweet William

Tulip

Verbena

Violet, Persian

Wax flower

Zinnia

Zinnia

INDEX

Other Fine Books From C&T Publishing:

For more information write for a free catalog:
C&T Publishing, Inc.
P.O. Box 1456
Lafayette, CA 94549
(800) 284-1114
http://www.ctpub.com
e-mail: ctinfo@ctpub.com

For quilting supplies:
Cotton Patch Mail Order
3405 Hall Lane, Dept. CTB
Lafayette, CA 94549
(800) 835-4418
(925) 283-7883
http:// www.quiltusa.com
e-mail: quiltusa@yahoo.com